IMAGES
of America

GREENCASTLE-ANTRIM REVISITED

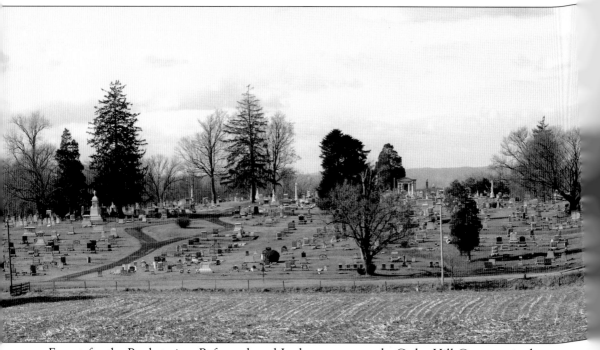

Except for the Presbyterian, Reformed, and Lutheran graveyards, Cedar Hill Cemetery is the final resting place for the preponderance of Greencastle-Antrim's founding fathers and mothers. The monuments of granite, whether they are small, large, or obelisk Victorian-era pillars, seem not adequate enough to tell a life's story with only a beginning and an end. The void in between is where life breathed. Whether they were infants who only lived a few weeks, mothers who died young, merchants, industrialists, or veterans, each person's story matters. Perhaps they have all been remembered with a tribute in a journal or an image somewhere. (Courtesy of Allison-Antrim Museum.)

On the cover: Please see page 93. (Courtesy of Allison-Antrim Museum.)

IMAGES
of America

GREENCASTLE-ANTRIM REVISITED

Bonnie A. Shockey and Kenneth B. Shockey
with the Allison-Antrim Museum

ARCADIA
PUBLISHING

Published by Arcadia Publishing
Charleston SC, Chicago IL, Portsmouth NH, San Francisco CA

Printed in the United States of America

Library of Congress Catalog Card Number: 2006940154

For all general information contact Arcadia Publishing at:
Telephone 843-853-2070
Fax 843-853-0044
E-mail sales@arcadiapublishing.com
For customer service and orders:
Toll-Free 1-888-313-2665

Visit us on the Internet at www.arcadiapublishing.com

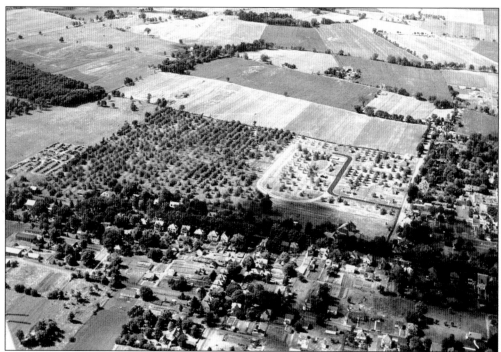

This photograph will evoke different memories for those who remember the orchards just south of East Baltimore Street than it will for younger generations who never knew that orchards and fields existed where the Lilian S. Besore Memorial Library, Orchard Circle Development, and the Greencastle-Antrim School District campus now lie. This aerial photograph was taken before Corning Glass Works came to town in 1960 and before housing developments replaced the patchwork of fields. Some generations can only imagine what it was like, and some generations will feel a melancholy yearning to see it just one more time. (Courtesy of Jack Phillippy.)

CONTENTS

ACKNOWLEDGMENTS

This pictorial history book would not have been possible had it not been for those who, long ago, packed up their cumbersome cameras, tripods, and wooden boxes, which held the glass plates, and loaded them into a buggy, on a wagon, a train, or a trolley. In 1880, there were no cameras such as a Brownie, Polaroid, 35 millimeter, video, digital, or cell phone. Yet the fascination with capturing images in the mid-1800s, by those who could afford a camera, was irresistible. Thankfully there was such a person in Greencastle-Antrim at that time, and his name was George Frederick Ziegler I.

Those who followed in Ziegler's footsteps included Pitt Carl, who not only took photographs, but also published the pictures as postcards. Alex Morganthal was another publisher of postcard photographs. Others were Harold "Penny" Pensinger, an avid local photographer who used his skills in World War II, and Jarvis Henson and Charles F. Besecker, whose interest in photography led them all over this geographical area. In the mid-20th century, Edwin Bittner, Isabelle Barnes, and Elizabeth Martin joined the group.

The keepers and collectors of the old photographs cannot be forgotten. Without them, few visual archives would have survived that now allow us to peek back more than a century into the daily lives of our ancestors in Greencastle and Antrim Township.

Ownership of cameras became more common during the 1950s, and although those hundreds of thousands of family photographs have only been seen by family members and are perhaps stored in lowly shoe boxes, they, too, are part of Greencastle-Antrim's history.

Thank you to my husband, Ken, who tirelessly worked beside me on this book, a labor of love. Thank you to Ted Alexander for writing the back book cover. Thank you to those individuals who did research, loaned photographs, and shared their stories about Greencastle and Antrim Township. Together we have all produced *Greencastle-Antrim Revisited*. Collectively it is our pictorial history book that holds memories for the greatest generation and for baby boomers, and for our children, grandchildren, and great-grandchildren, it is our gift to them—a pictorial legacy.

—Bonnie A. Shockey
President, the Allison-Antrim Museum

INTRODUCTION

For more than two centuries, Greencastle-Antrim's history has mirrored that of the nation. Greencastle-Antrim's history is American history. As the post–Civil War industrial period boomed, the community saw many changes. With the coming of the steam engine and then the gasoline engine, small-town craftsmen like shoemakers, tailors, blacksmiths, milliners, cabinet makers, carriage and wagon makers, makers of agricultural equipment such as grain cradles, and many others were eventually put out of business by industries that mass produced at cheaper prices the necessities of daily life.

Jacob B. Crowell built Greencastle's first industrial park in a quarter-block area of the 300 block of South Washington Street. The complex included a pattern house, foundry, assembly building, and steam-powered machinery with which the company produced a variety of items for construction, farming, and household needs. Crowell was well known for the Willoughby Grain Drill, which hoed, fertilized, and deposited seeds with one implement. The company also made steam-powered sawmills, horse-drawn hay rakes with either wooden or iron hub wheels, fertilizer drills, and corn shellers among other products. In 1899, the Geiser Company of Waynesboro bought the Crowell complex for the specific purpose of manufacturing Geiser's first gasoline engine. Prior to that, Geiser engines, all of which were made in the Waynesboro area, were steam powered.

The Omwake brothers opened a business on North Carlisle Street in 1887, which provided the services of grist and lumber milling for the Greencastle-Antrim area. The many water-powered mills located in Antrim Township, which had served the area for more than a century, eventually closed because of the use of steam and electric power.

The Progressive Era of the early decades of the 20th century brought even more changes to the community. In 1915, Landis Tool Company of Waynesboro bought the Flinchbaugh industrial complex in Greencastle and employed as many as 150 men and women. Near the end of World War II, the complex was sold again. Through the first six decades of the 20th century, other businesses in Greencastle included the stockyard, orchards, hatcheries, a hosiery mill, garment factory, a shoe company, bakeries, car dealerships, garages, a pipe nipple manufacturing plant, food and meat processing companies, and a mobile home manufacturer. The largest single employer in this area was Grove Manufacturing, with Landis Tool Company, Landis Machine Company, Fairchild, and Letterkenny Army Depot in nearby towns also providing employment to many local men and women.

The Boreland Academy, a private school located in the study house of the Moss Spring Church during the 18th century, provided a classical education for young men from throughout

the region. Later a school for girls, run by Anna Brown Rankin, taught academics as well as sewing and knitting.

Victoria Robinson and George Frederick Ziegler I each opened private schools in the 1870s. Robinson taught etiquette, correct posture, and elementary education subjects at her Select School for Girls. Ziegler's school, called the "Academy," accepted both boys and girls. The curriculum provided academic courses for college preparation, art, and music. It closed in the 1886, and was one of the last privately operated schools in Greencastle. By 1900, all private schools in Greencastle bowed to the public education system.

The passage of Pennsylvania's Free School Law of 1868 resulted in enormous progress in education in Greencastle. A two-story school building, which consolidated all the one-room schools in the town, was built on the corner of South Washington and East Franklin Streets in 1868. Greencastle's first three-year high school did not begin until 1875; it was also located in the elementary education building. Antrim Township, on the other hand, continued educating all of its children in 24 one-room schools and three two-room schools. Unless their parents could afford to pay tuition for their children to attend Greencastle's high school, the children of Antrim Township only received an eighth-grade education. Unlike Greencastle eighth graders entering the high school, township children were required to pass an entrance exam. In the fall of 1955, two new elementary schools opened in Antrim Township, which along with the Brown's Mill School, consolidated all the students from the township. The Greencastle-Antrim community continued to experience rapid growth, the result of which was a new high school building being opened in 1960 on South Ridge Avenue, quickly followed, only eight years later, by the opening of the middle school. From 1955 to 1971, school enrollment grew to 2,795, an increase of over 60 percent.

During the 1800s, social life in the community revolved around the church. Thirteen churches served the area. By 1970, the Greencastle-Antrim community had 27 churches. Today more than 50 churches serve the spiritual needs of the community.

In 1871, the Town Hall, Greencastle's first cultural and special events center, was opened. The second floor contained a huge auditorium. It was often filled to capacity for theatrical and musical presentations, graduation ceremonies, reunions, dinners, dances, lectures, and Old Home Week events. The headquarters for the first Old Boys Reunion and the succeeding three Old Home Week celebrations were located in the Town Hall from 1902 to 1911. The Town Hall remained the center of entertainment for the community until 1913, when it closed due to competition from the new silent movie theater, the Gem Theater, across the street.

Community baseball games as well as children's recreation was centered at the Jerome R. King Playground after its dedication in 1923. From the early 1920s into the 1960s the following provided recreation locally: billiard parlors, bowling alleys, soda fountains, social clubs for men and women, movies, radio, television, school athletic programs, the Sportsman Farm, Scouting, square dancing, the Teen Canteen, drive-in food establishments, and church-sponsored activities.

Few generations since the area's settlement have escaped the tragedy of war. During the 20th century, Greencastle-Antrim men and women proudly served in World War I, World War II, the Korean War, the Vietnam War, and the first Gulf War.

In 1800, about 800 or more people lived in Greencastle; and Antrim Township's census claimed approximately 1,650. In 1900, the population of Greencastle was 1,463 and Antrim's was 4,556. The 1970 census showed Greencastle with 3,293 residents and Antrim Township with 7,378.

One

ANTRIM TOWNSHIP REVISITED

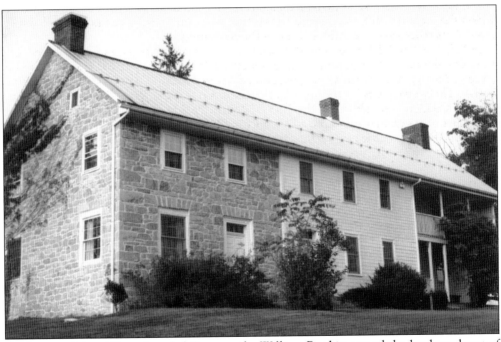

At the time John Allison founded Greencastle, William Rankin owned the land northeast of Greencastle, on which this brick, limestone, and early log structure now sits at 9762 Brown's Mill Road. The log portion, being the oldest section of the home, was likely constructed in the 1700s. Rankin and Allison entered into an agreement on March 8, 1785, by which Rankin would supply, in perpetuity, Greencastle with fresh water from Moss Spring that was situated on his property. (Courtesy of Sandra Kirkpatrick.)

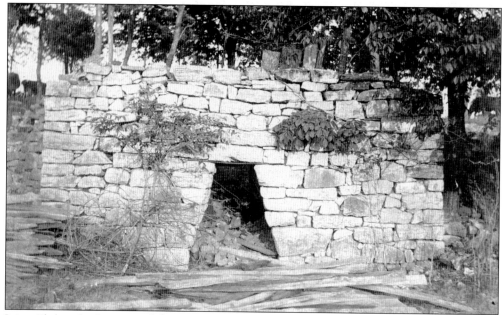

It is said that this limestone kiln was originally located on the Snively homestead property near Shady Grove. Lime kilns were very prevalent in this area because of the abundance of limestone. The kilns burned limestone with wood, which reduced the stone to lime. The lime was primarily used with sand to make mortar, which was likely used in the construction of buildings on the property. (Courtesy of the Lilian S. Besore Memorial Library.)

Very few working 18th-century gristmills still existence. A Hurst frame and four cog gears are seen in this rare photograph of Rankin's Mill, which was once about one mile northwest of town, on the south side of Williamson Road. The frame held the gears and buhrstone together. Muddy Run powered the waterwheel shaft, which turned the series of gears and eventually the buhrstone located on the second level. The stone was balanced on top of a shaft. (Courtesy of Alice M. Brumbaugh.)

When electricity became available, the water-powered township mills were replaced with more centralized mills, such as Omwake Brothers at 201 North Carlisle Street. In addition to a gristmill and lumber mills, the operation also sold coal. The drive-through coal shed was built to accommodate horses and wagons. The wagons were positioned under one of the chutes seen in this photograph, loaded with coal, and then were weighted on Fairbanks scales before paying. (Courtesy of Allison-Antrim Museum.)

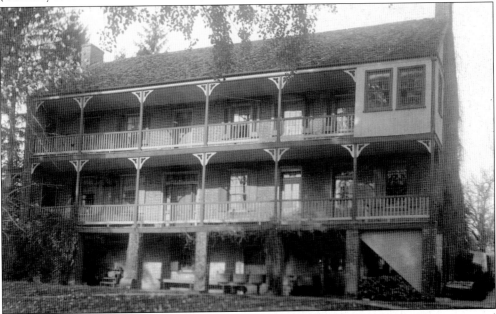

This Snively home, known as the "Mansion House," at 985 Buchanan Trail East is situated on what was part of a thousand acres or more of land owned by Joseph Snively Sr., son of Jacob Snively. The homestead was passed on to succeeding generations. Joseph Snively Jr., a Mennonite, was a surveyor by trade and was elected by the Whig party as a member of the 1838 constitutional convention. (Courtesy of Glen L. Cump.)

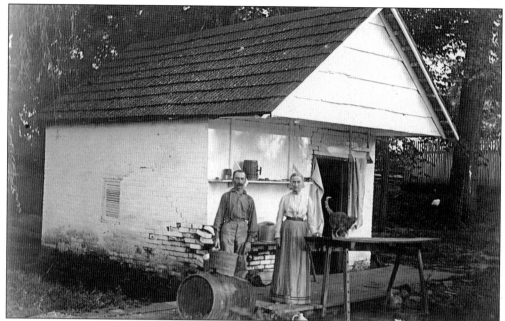

Brother and sister, Will and Kate Snively, are standing in front of the cantilevered springhouse, which was on the property of the Snively home at 985 Buchanan Trail East. Some of the everyday items used at the springhouse can be seen in the photograph, including a crock, a barrel, a bucket, and a firkin. The continuous length of linen, at the right of the doorway, was a hand towel. (Courtesy Glen L. Cump.)

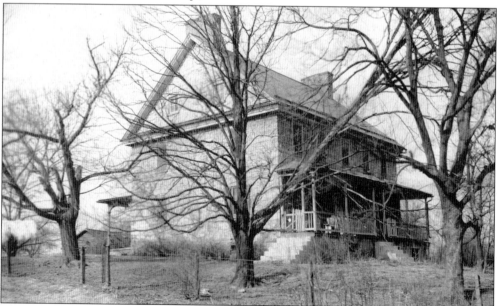

In 1781, Andrew and Susan Snively built this limestone house at 763 Zarger Road, which is about three-tenths of a mile off Grindstone Hill Road. The view from the front of the house overlooks the spring, where a springhouse still stands. Andrew's father, Jacob Snively, was one of the earliest settlers in Antrim Township and owned thousands of acres of land. The name Snively evolved from the surname Schnebele. (Courtesy of Ed Zarger.)

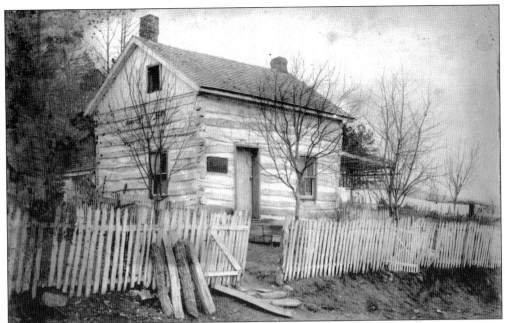

In both the township and the town, the first homes were made of logs. It was a quick way of providing shelter for one's family and it utilized readily available materials of the time period. Many log homes still survive to this day, but they are seldom recognized because the exteriors have been covered with clapboards, bricks, or other siding materials. This photograph is from the Ziegler glass plate negative collection. (Courtesy of Allison-Antrim Museum.)

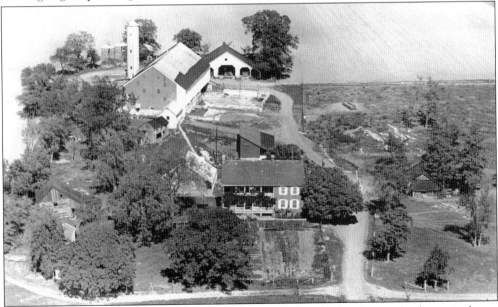

John and Sarah Eshleman came to this farm in the late 1820s when only the springhouse existed. They built the barn in 1848 and the large house in 1860. Five generations of the family have owned this property with the sixth generation having been raised here. Prior to Interstate 81 being constructed, the lane exited onto Route 11. The current address is 405 Milnor Road. (Courtesy of Terry Musselman.)

This 1968 photograph shows the evolution of the building, which in 1859 was the Jacob Brumbaugh tavern, one of the places John Brown stayed while planning his raid on Harper's Ferry. Along the pike to Hagerstown, the tavern was located on the southeast corner of the square in Middleburg, now known as State Line, and was the only establishment of its kind at that time in Antrim Township. (Courtesy of Harry Tressler.)

Just north of State Line, this farmhouse was built in the mid-19th century and was owned by David and Mary Martin during the Civil War. It is documented that James Longstreet and Gen. Robert E. Lee and their troops stopped at the Martin farm on their way to Gettysburg. Around 1940, Herbert and Jennie Swope purchased the farm; the house was razed in 1997. (Courtesy of Mike Burger.)

At five years of age, little Alice Martin pumped water from the wooden "cucumber" pump and offered it to Gen. Robert E. Lee when he stopped in Middleburg (State Line) for a drink of water after crossing the Mason-Dixon Line into Pennsylvania. Both the wooden pump and the more modern metal pump were removed years ago. The pump was on the David and Mary Martin farm. (Courtesy of Mike Burger.)

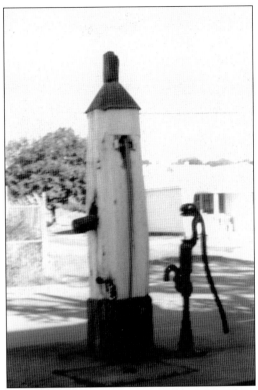

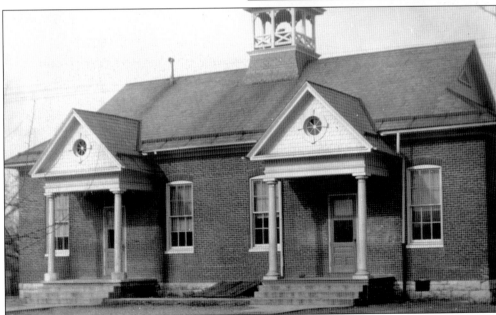

The Middleburg Grammar School was built in 1893 on East Avenue. It was a two-room brick building that served the students of the State Line area until the fall of 1955 when the South Antrim School opened its doors. Grades one to four spent their days in the left-hand room and the students in grades five to eight were on the right side of the building. (Courtesy of Middleburg/Mason-Dixon Historical Society.)

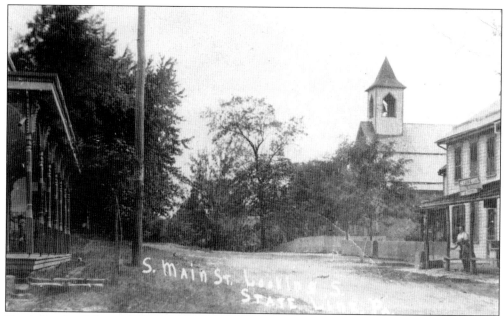

Hartle Brothers' General Merchandise store is located in the building on the right with the Trinity United Brethren Church in the background. The picket fence runs for a long distance along the street and around the buildings. The fences were used to keep the village's free-roaming sheep from grazing in the yards of the property owners. State Line was also known as Muttontown. (Courtesy of Middleburg/Mason-Dixon Historical Society.)

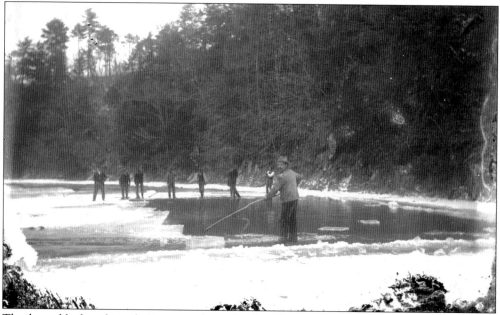

The large blocks of ice, being sawn from the first dam's pond, were likely stored in one of about 12 insulated brick icehouse buildings around town. The ice would then be sold by the pound during the summertime. As there was an icehouse behind the Franklin Hotel, it is likely that some hotels controlled their own supply. It is known that owners of large bodies of water sometimes charged a fee for harvesting ice. (Courtesy of Allison-Antrim Museum.)

There are a number of George Frederick Ziegler I glass plate negative photographs in which the same three ladies appear as in the cover photograph. One of those ladies was his wife, Anna Robinson Ziegler. In this photograph, two of the three ladies with him have exited from the west end of the Martin's Mill covered bridge. Anna is on the right. The building on the right is the northeast corner of Martin's Mill, which no longer exists. (Courtesy of Allison-Antrim Museum.)

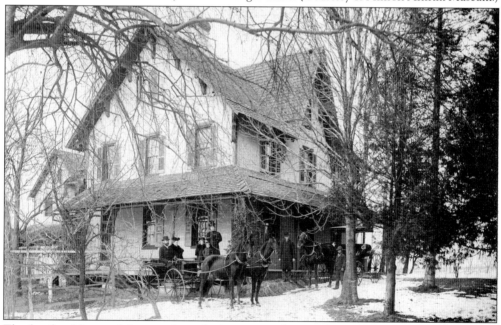

The family of four and the couple in the buggy, seen here in front of the Scott Fleming family cottage at 11359 Williamsport Pike, are just getting ready to leave for an unknown destination. Travel was carefully planned as one could not just grab the keys and leave. The horses had to be retrieved from the stable and hitched to the buggy or wagon, neither of which had heated seats. (Courtesy of Allison-Antrim Museum.)

H. P. McLAUGHLIN,

DEALER IN

Dry Goods, Notions, Groceries,

Hats, Boots, Shoes, Salt, Coal, &c.

STATE LINE, PA.

☞Produce taken in exchange for Goods at Highest
Market Price.

In the late Victorian period, business cards, such as this one for H. P. McLaughlin, were common advertising pieces, as are business cards of the 21st century. Considering the wide range of goods carried in McLaughlin's store, residents of the State Line area did not have to travel very far to purchase what they needed, either with cash or by barter. (Courtesy of Mike Burger.)

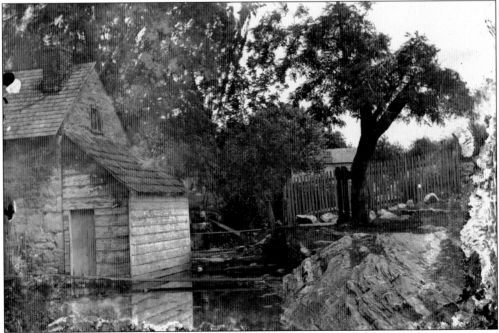

Prior to this spring being known as Tayamentasachta, it was called Poplar Spring, which may lead one to think that there was an abundance of poplar trees in the area. Those living in Antrim Township who had springs on their land used nature's refrigerator to store crocks of butter, pails of milk, and other perishables in the cold water. With the convenience also came the chance that containers might be upset by an unexpected heavy rain. (Courtesy of Allison-Antrim Museum.)

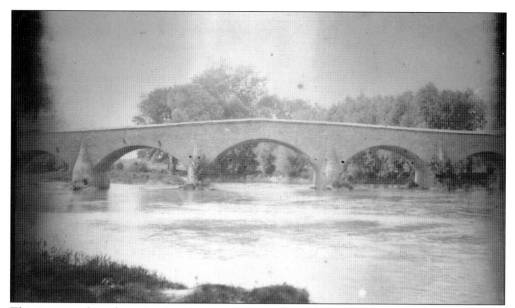

This is a rare glass plate negative photograph from about 1885 of the five-arch limestone bridge, which used to be located about one mile west of Greencastle. It was constructed in the early 1830s during the building of the Waynesboro-Greencastle-Mercersburg Turnpike. Being the only five-arch bridge of its kind in Franklin County, it was very picturesque. The bridge closed to traffic in 1941 when Route 16 was rerouted about 200 feet north. (Courtesy of the Lilian S. Besore Memorial Library.)

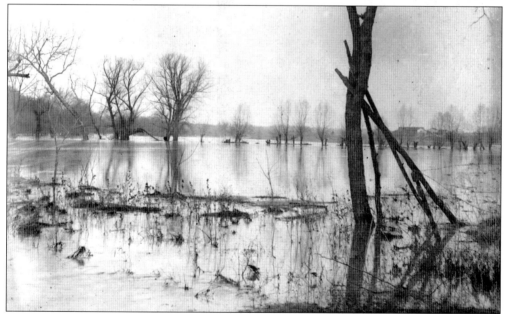

From this point of view, one wonders how George Frederick Ziegler I could have been standing on dry ground when he took this photograph. For Antrim Township residents, this scene may be visible about every 30–40 years. The low lying meadows and fields along the banks of the Conococheague Creek easily flood in this manner after heavy rains over a number of days. (Courtesy of the Lilian S. Besore Memorial Library.)

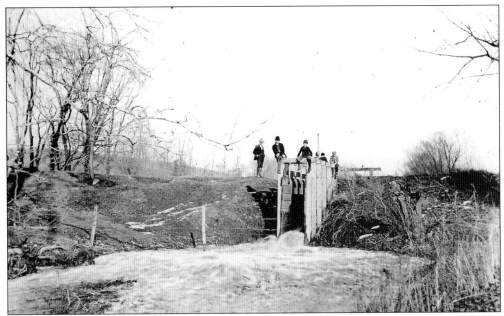

Four young lads straddle the gate area of the first dam, while two men keep a watchful eye. The first and second dams provided the power to operate the McCauley Mill, later known as the Antrim Mill. The mill was located on the west side of Grant Shook Road south of Route 16. Had their mothers been present, the boys would have likely been standing on solid ground. (Courtesy of Allison-Antrim Museum.)

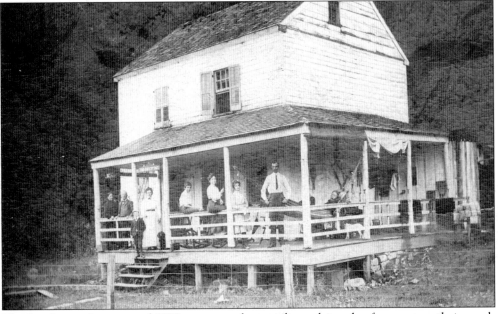

The family seen here around 1900 appears to be spending a leisurely afternoon on their porch with their family or friends. They have named their home Fair-Sha Cottage. This house is typical of the lath and clapboard homes of that era. Before it was razed in the 1990s, it stood near the springhouse at the intersection of Craig Road and Route 11 north of Greencastle. (Courtesy of A. Isabelle Barnes.)

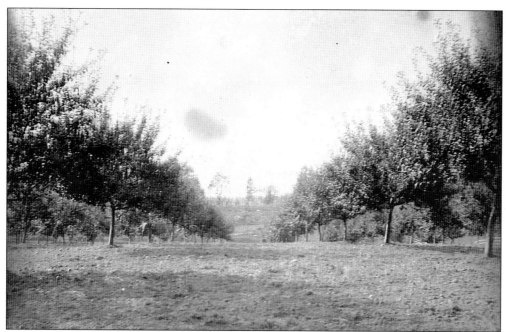

This glass plate negative was taken by George Frederick Ziegler I around 1900. The fertile ground of Antrim Township produced abundant crops in the fields, the orchards, and the backyard home gardens. The ripe fruit of the trees, likely apples, can be seen scattered on the ground near the trees. (Courtesy of the Lilian S. Besore Memorial Library.)

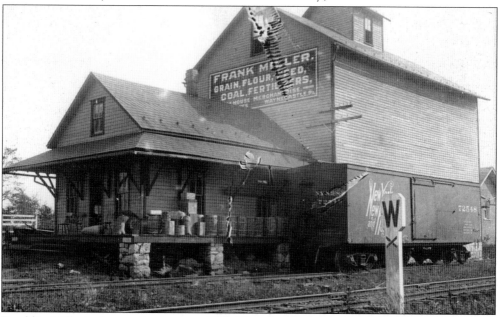

Franklin Miller's elevator business at 3289 Waynecastle Road along the Western Maryland Railroad tracks opened on the extreme eastern border of Antrim Township in 1900. This wooden structure was destroyed by fire on May 22, 1922, but Miller rebuilt everything by 1923 using brick. As he was 75 years old, his son, Charles F. Miller, bought the business, which remained open until 1978. (Courtesy of A. Isabelle Barnes.)

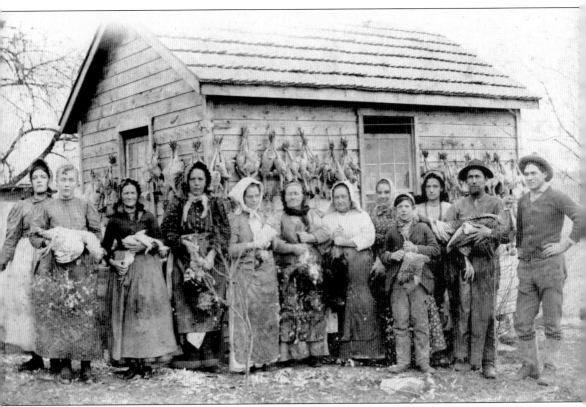

This shanty, which still stands at 2666 East Weaver Road, was owned by James L. Dentler, a huckster during the 1880s. He bought chickens and cleaned and sold them locally. He also shipped them by rail to other markets, including New York City, where members of the Jewish community would only purchase them if the heads were not removed. With feathers everywhere, this area of the township was appropriately known as Feathertown. (Courtesy of Fred Schaff.)

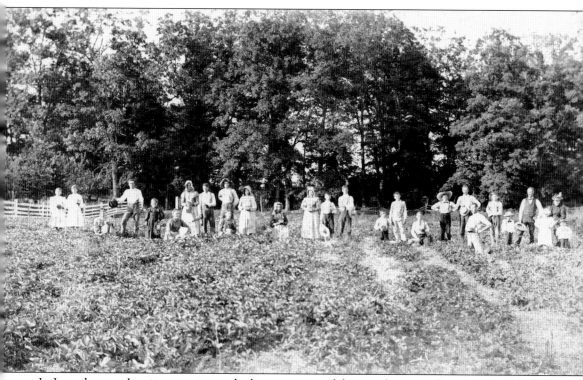

In June the strawberries were ripe in the huge expanse of the strawberry patch and they needed to be picked at the most opportune time. In order not to loose the perishable fruit, many hands were needed at Wishard's orchards in the Kauffman's Station area, and everyone, including the very young, was expected to help with the daunting task. While a percentage of strawberries may have been kept for the local market, many boxes were likely transported to the Kauffman train station where they were shipped to farther destinations. (Courtesy of Raymond Wishard.)

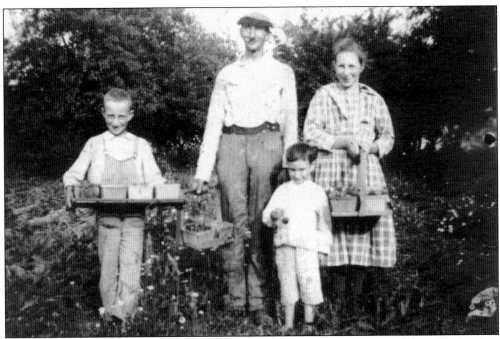

On a much smaller scale, the A. A. Hicks family has just finished picking their ripe, sweet strawberries from their patch at home. Strawberry jelly and jam preserves were made as a way of enjoying the early summer fruit year round. Of course, strawberry shortcake would have been that evening's dessert. Pictured from left to right are Alvin Hicks, Albertus Ambrose Hicks (father), Glenn Hicks, and daughter Velda Hicks. (Courtesy of Ferne Trittle.)

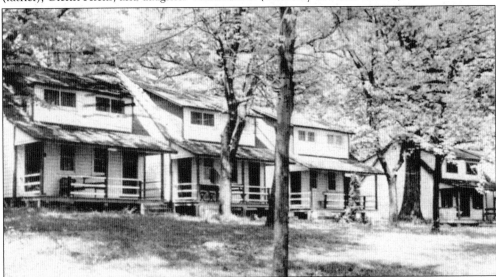

In 1917, the United Brethren Church purchased land at 7693 Brown's Mill Road from the Rhodes family heirs and built a tabernacle and dining hall for the purpose of church retreats. In 1934, summer cottages, such as those in the photograph, were built, followed by the construction of the Christian Education building and four cabins. The two-phase Meadows Conference Center project was completed about 2002 and in 2005, Rhodes Grove was incorporated, independent of the Church of the United Brethren in Christ. (Courtesy of Lilian S. Besore Memorial Library.)

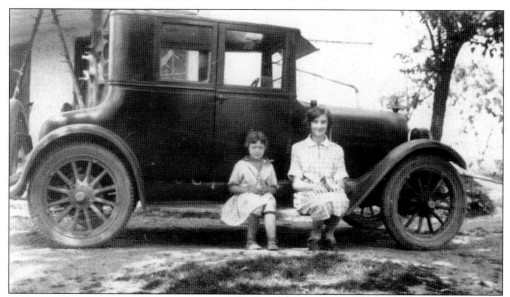

Parked in front of the Atherton home at 2206 Buchanan Trail West, Dood Sellers Anderson (left) and Bertha "Sis" Atherton Johnson are sitting on the running board of a Durant car around 1923. William C. Durant was the founder of the General Motors Corporation and was involved in the early automotive industry along with David Buick and Louis Chevrolet. Undoubtedly someone in Greencastle had a license to sell Durants. (Courtesy of Oliver Goetz.)

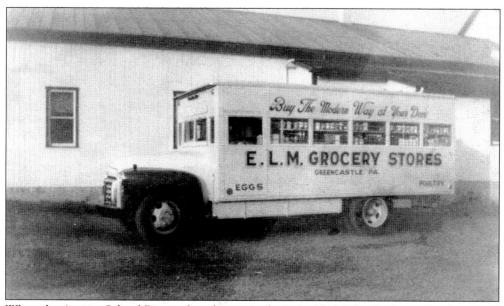

When the Antrim School District bought its own buses in 1928, J. Ira Eshleman lost his school bus contract. Undaunted Eshleman removed the seats, installed shelves, and stocked his two buses with grocery-market items. He hired David Lehman and Norman Martin, his sons-in-law, and the E. L. M. Grocery Store grew to five stores on wheels catering to township families. In 1949, the partnership dissolved and Lehman sold the stores and established Lehman's Egg Service. (Courtesy of Galen Buckwalter.)

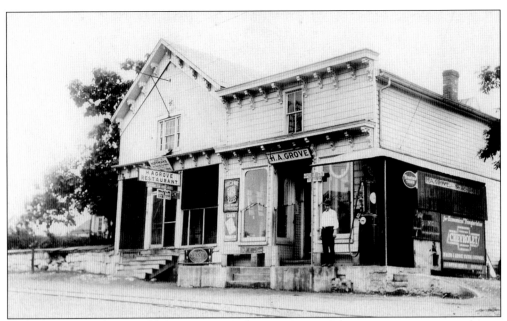

Out of seven proprietors of the grocery store and post office in Shady Grove, Harry A. Grove was the fifth. Melchi Snively built and opened the business in 1848. This photograph was taken prior to 1932, as the trolley tracks are still evident. The gas pump and the Chevrolet advertisement, which touts, "for Economical Transportation," are evidence of why the trolley company went out of business. (Courtesy of Lloyd "Sonny" Rowe Jr.)

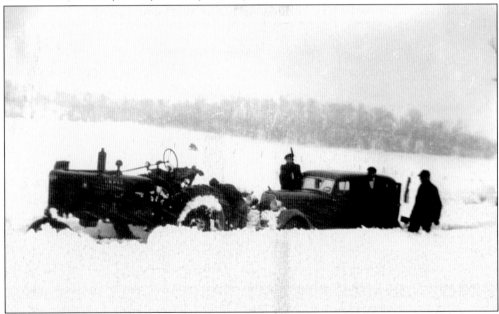

On Palm Sunday in 1941, a driving snow storm blew into the Greencastle-Antrim area, which caused difficulties traveling that day. At the car, from left to right, are Lil, Harne, and John Brady, whose car got stuck in the driveway at 2206 Buchanan Trail West. The Athertons, who lived at the farm, came to the Bradys' rescue by hitching the tractor to the car and pulling it out. (Courtesy of Oliver Goetz.)

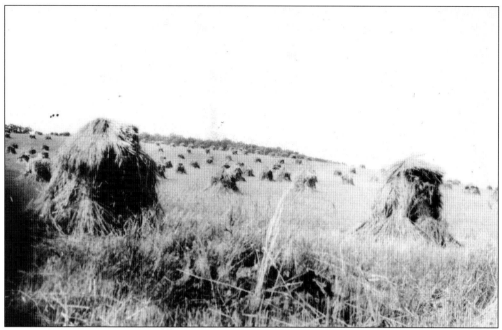

Up until the latter half of the 20th century, these architectural mushroomlike shocks of wheat, which dotted fields along the township roads, were very familiar during the harvest season in Antrim Township. The wheat was cut in the field with a binder. The small bundles of wheat, tied by the binder, were gathered into shocks—a job for the boys. The shocks were then put on wagons and taken back to the barn for threshing. (Courtesy of Oliver Goetz.)

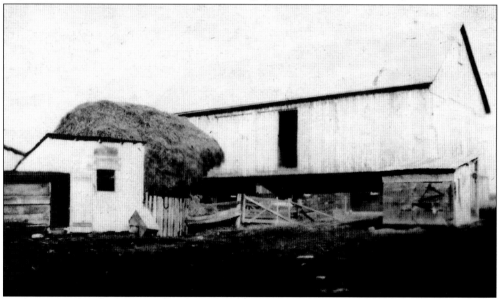

A typical straw stack, such as this one at the Hemminger farm at 774 Colonial Drive, was the last step in the threshing process. After the wheat was cut and brought to the barn, it was threshed by machine during this time period. The thresher threw out the stalks, which were stacked to form the straw stack. The straw from this stack would be used for livestock bedding. (Courtesy of Oliver Goetz.)

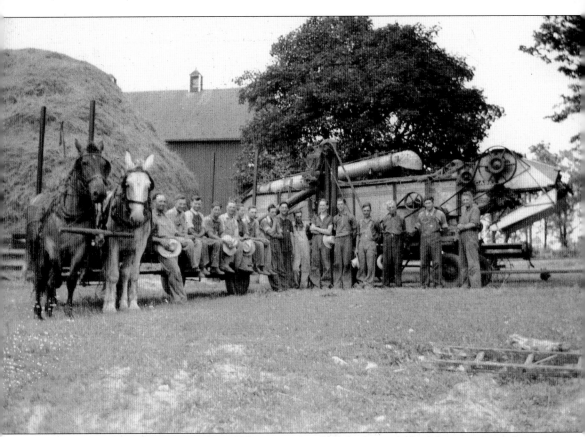

Although modern mechanization (the Case thresher) had eased the labor-intensive days on farms by 1941, horses were still needed and utilized. Judging by the size of the straw stack used for livestock bedding, this crew of 16 had finished a long day of wheat harvesting and threshing at the William Oaks farm on Antrim Church Road. In this era, after the wheat was cut and brought to the barn, it was threshed by machine. The thresher threw out the stalks, which were then stacked with a rounded crown. This helped the rain run off without soaking through. Threshing crews made of fathers and sons from 10 area farms traveled from one farm to another until all the fields had been cut. One area man owned the thresher, which was used on all of the farms. The ladies of the home worked all morning to prepare dinner. At lunch time, the crew would come in, wash up using wash basins and clean towels that were set out for them, and sit down at a long stretch of tables. (Courtesy of Gladys Oaks McCrae.)

Two

GREENCASTLE REVISITED

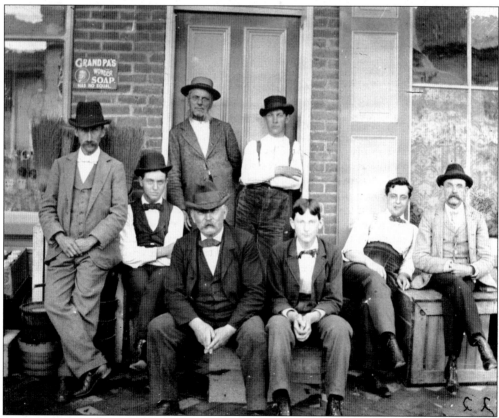

This dapper looking group of townsmen, young and old, took time from their day to be photographed in front of a shop at the old Town Hall building, which housed numerous storefronts on the ground level. The Town Hall was a center of activity in Greencastle between 1871 and 1913. This photograph is from the Ziegler collection of glass plate negatives. (Courtesy of Allison-Antrim Museum.)

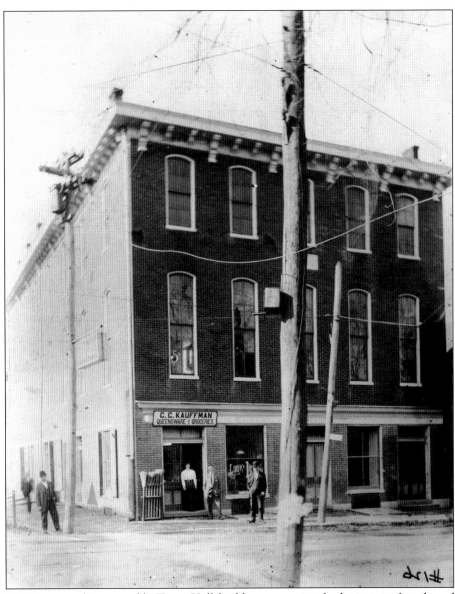

In 1871, Greencastle's venerable Town Hall building was open for business, after three local investors established the Town Hall Company. The construction of the building was completed by local industrialist, Jacob B. Crowell. The original architectural design of the building can be seen here. The first floor provided space for storefronts and businesses. When the building opened, there was no electricity, radio, television, movies, CDs, or DVDs. The Town Hall was Greencastle's first cultural and special events center. The second floor, a huge auditorium, provided an area for presentations, including the town's first silent movies, theatrical productions, musicals, class plays, concerts, graduation ceremonies, reunions, cakewalks, dinners, dances, lectures, and Old Home Week events. From 1902 to 1911, the Old Boys Reunion and Old Home Week headquarters was in the Town Hall. Fraternal organizations and the Grand Army of the Republic met on the third floor. In 1911 or 1912, when Harry W. McLaughlin annexed a theater onto his hotel, special events and audiences were attracted away from the Town Hall. Within one year, the Town Hall was sold. (Courtesy of Frank Ervin.)

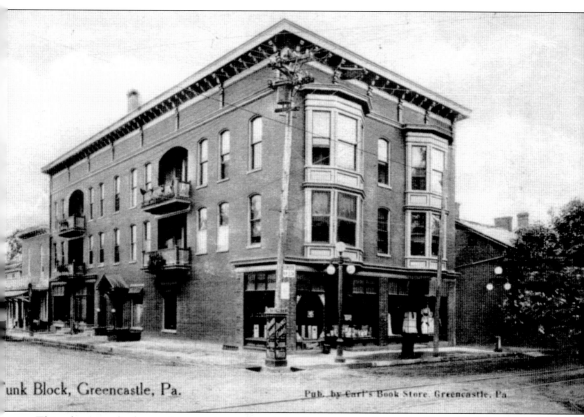

unk Block, Greencastle, Pa.

Pub. by Carl's Book Store, Greencastle, Pa.

This photograph shows the exterior renovations that were made to the Town Hall building in 1913 when it was sold. Inside the second and third floors were converted into beautiful apartments with chestnut wainscoting and hardwood floors. The first floor accommodated storefronts and businesses. Gradually the building fell into disrepair, but in 2005 a new property owner began renovating the building to its original glory. The old Town Hall was again in the good and caring hands of someone who respected and honored its past. Very sadly, on the bitter cold morning of Thursday, January 26, 2005, the fire alarm sounded. With flames shooting 20 feet into the air, about 70 firefighters from the Rescue Hose Company No. 1 and numerous neighboring fire companies worked on extinguishing the flames. Thirteen residents of the apartments escaped injury. For the time being, there is a gaping wound in the heart of Greencastle. The community now looks toward the future when another building will fill the space at 5 South Washington Street, where new memories will be made. (Courtesy of the Lilian S. Besore Memorial Library.)

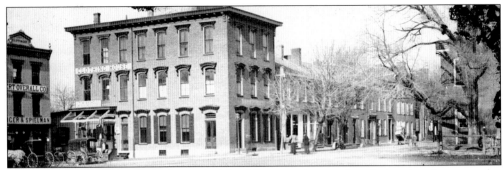

This *c.* 1895 street scene from a day in the life of Greencastle was taken during the winter months. Heavy coats are hanging outside the tailor's entrance and a carriage is enclosed against the elements. To the right on North Carlisle Street, a baggage cart, likely the Franklin Hotel's, appears to be loaded with trunks headed to the train station. (Courtesy of Allison-Antrim Museum.)

Today one can only imagine what it was like to travel in a carriage during the winter months with snow on the ground. It must have been very important business that brought this person out into the elements, as the rest of the square is empty. Although enclosed against the winter harshness, the carriage was unheated, unless there was a pan of hot ashes for warming feet. (Courtesy of Lloyd "Sonny" Rowe Jr.)

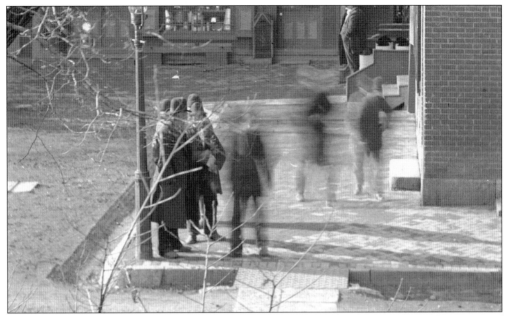

Note a section of the trunk line (running along the curb edge at the square), which was part of the zigzagging watercourse that ran throughout the borough to supply water to the residents. At intersection crossings, water flowed through iron pipes or brick culverts. Large wooden dipping boxes, filled with water from the trunk line, were sunken into the ground on each street and many private lots. (Courtesy of Allison-Antrim Museum.)

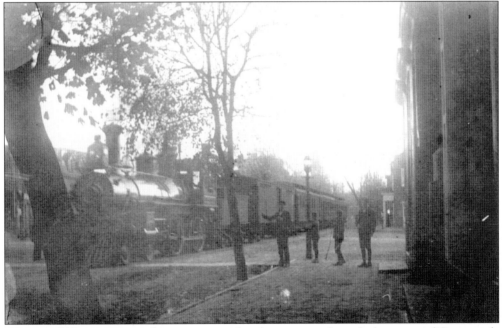

What would be an awe-struck occurrence today if a train ran through the center of Greencastle was but an everyday happening for the townspeople from the late 1800s to the early 1900s. In fact, at the height of the railroad's heyday, 14 trains went through town every day, half of them north and half south. (Courtesy of the Lilian S. Besore Memorial Library.)

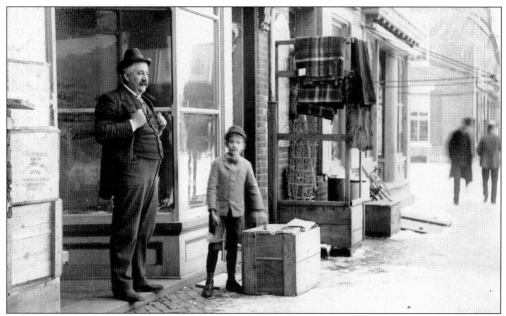

Gideon Rauhauser, on the left, and an unknown lad are seen in front of Carl's Book Store at 8 Center Square in Greencastle. With Pitt Carl, the bookstore's proprietor, also being the town's telegrapher, the bookstore was the first to receive all the breaking news, and therefore was the place to congregate for spirited discussions. Rauhauser and his brother Joseph were leading businessmen of the community in the late 1800s. (Courtesy of the Lilian S. Besore Memorial Library.)

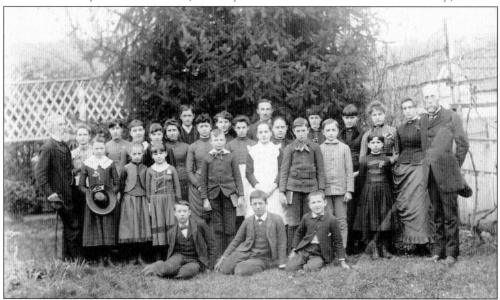

George Frederick Ziegler I graduated from Amherst College and the Princeton Theological Seminary and was a student of the Universities of Berlin and Heidelberg. In 1872, he opened a select school for boys and girls, but closed it in 1886 when he accepted the professorship of English literature and French at Wilson College in Chambersburg. On the extreme left is music teacher Professor Holm of Hagerstown, and on the far right is Ziegler. (Courtesy of Martha Ziegler and George Fred Ziegler IV.)

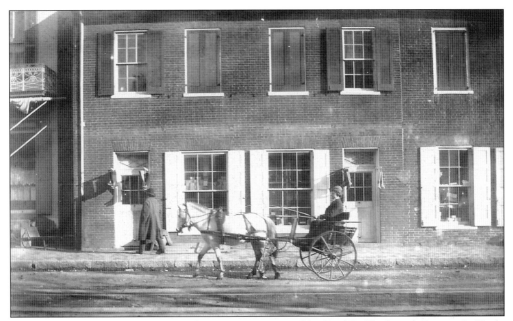

Heck Brothers, established on April 8, 1901, was owned by Fred Z. Heck and George S. Heck. On the west side of the Ziegler building at 3 Center Square, there were three storefronts, each divided from the other by a wall. Shoes were sold in the left shop and dry goods and a general store were in the other two. The unknown lady is riding in a pony cart. (Courtesy of Lloyd "Sonny" Rowe Jr.)

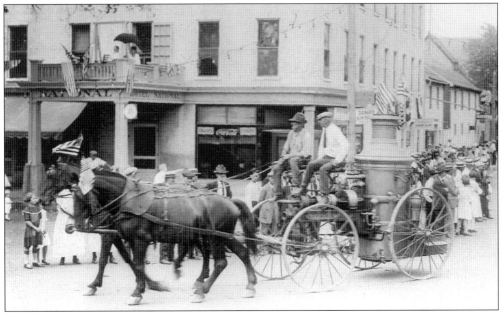

The Rescue Hose Company No. 1's 1883 Silsby steam engine was a hand-pulled apparatus; it was only pulled by horses in parades. As it was steam operated, when the fire bell sounded, the firemen immediately had to get a fire started in the firebox by using kindling. Once the fire was sufficiently burning, coal was added in order to build a good head of steam. (Courtesy of Rescue Hose Company No. 1.)

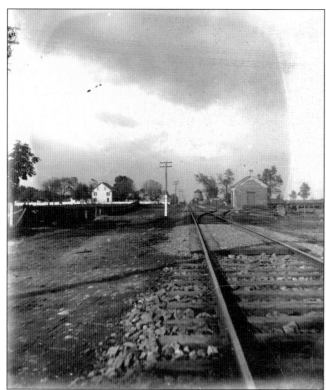

A water tank stood along the east side of the railroad tracks in the vicinity of 255 North Carlisle Street. A stream from a spring on land originally owned by William Rankin supplied water for the tank, which was used for the steam-powered train engines. In the middle of the picture, the gravel area likely indicates the intersection of Chambers Lane (to the right) and North Carlisle Street. (Courtesy of Allison-Antrim Museum.)

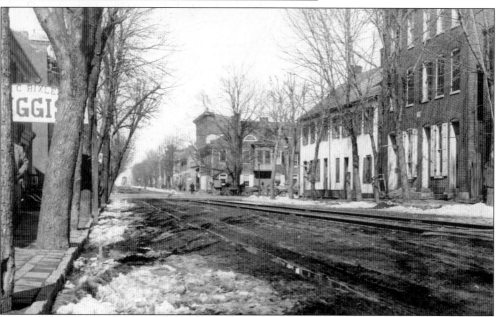

Points of interest in this *c.* 1908 view of Carlisle Street include the abundance of horses and wagons, the brick sidewalks, the unpaved street, and the water tank at the end of North Carlisle Street. The three-story building in the center of the photograph is the Franklin Hotel, built in 1879. Joshua Yous is credited with constructing the town's first three-story building on the right. (Courtesy of Mary Zielger Glockner.)

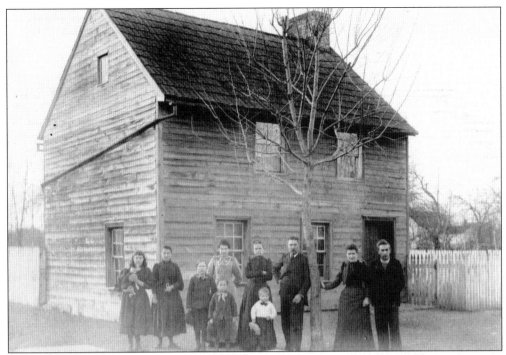

This weatherboard home at 63 South Jefferson Street was the home of Adam and Lydia Hoke Pensinger. Considering the size of the chimney, it was probably heated with one large fireplace or one fireplace on the first floor and one on the second floor. It could not have been very warm at the time. The family in the photograph is that of Horace G. Pensinger. (Courtesy of Allison-Antrim Museum.)

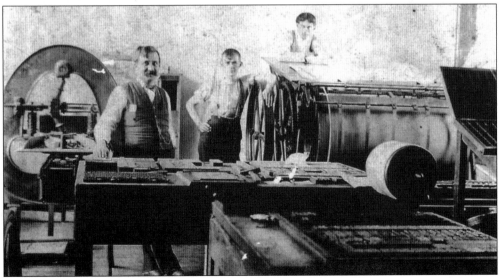

A snapshot was taken from a more laborious time of newspaper printing in the job room of one of Greencastle's newspapers. Greencastle's first weekly newspaper in 1849 was the *Conococheague Herald*, which became the *Valley Echo*. In 1893, William H. Kreps consolidated the *Valley Echo* and the *Pilot* into the *Echo Pilot*. G. Fred Ziegler II bought the *Echo Pilot* in November 1925. The name still remains. (Courtesy of Lloyd "Sonny" Rowe Jr)

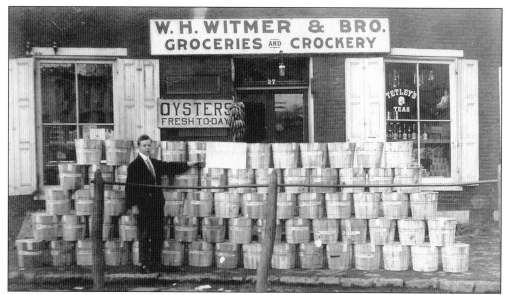

W. H. Witmer and Brothers Groceries was located at 27 Center Square (southwest quadrant) at the time this photograph was taken around 1910. Fresh oysters came to town by train and bananas were hung in large bunches. The store specialized in Tetley teas, and the 10¢ wooden buckets held hard candy that was ordered by town and township teachers as Christmas treats for their students. (Courtesy of Lloyd "Sonny" Rowe Jr.)

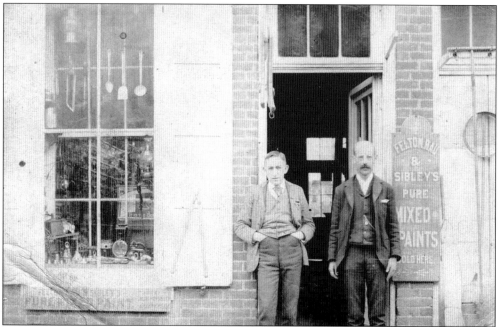

Beginning in 1853, Jacob Pensinger operated his hardware store in the above building, which was located at 6 East Baltimore Street. Edgar Pensinger, nephew of Jacob, became the sole owner of the business in 1908. The Pensinger family owned the century-old business from 1853 until the mid-1900s. (Courtesy of Evelyn Pensinger.)

This view of the Pensinger hardware building, after windows were enlarged and awnings were added, shows the kind of improvements made to places of business around 1910. The building was purchased and razed in 1916 by Charles B. Carl, who built a three-story brick building that became Carl's Drug Store. (Courtesy of Evelyn Pensinger.)

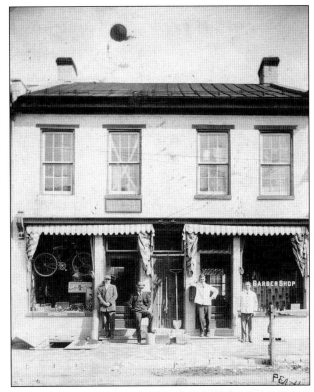

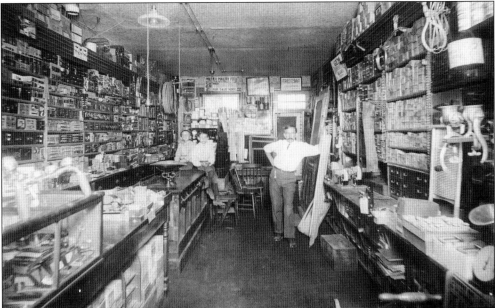

Until time travel becomes a reality, it is only through the camera's eye that one can step back into time. Not unlike 21st-century hardware stores, shelves in the Pensinger hardware store were stocked with small boxes and drawers filled with hundreds of small things, early-20th-century lawn mowers, and doors. Unlikely to be found in today's stores would be washboards, poultry feed, and meat grinders. Edgar Pensinger is on the right. (Courtesy of Joyce Pensinger Berger.)

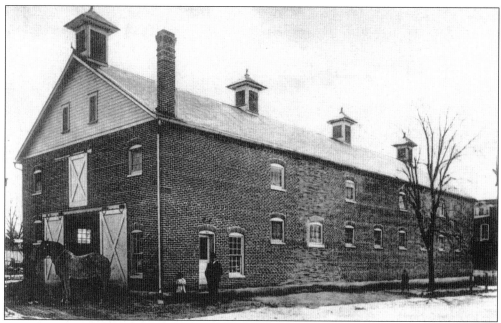

When Harry Wertz McLaughlin built his hotel at 104 East Baltimore Street in 1904, he also built a livery stable for his patrons' convenience. Aware that fire had sometimes destroyed other hotels' stables, McLaughlin built his livery of brick. The horses were boarded in stables on the first level, while a hand-operated pulley lifted the carriages, via elevator, to the second floor, where they were parked. (Courtesy of the Lilian S. Besore Memorial Library.)

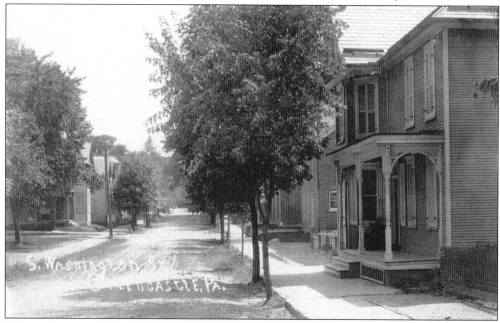

The residence on the right is 45 South Washington Street, and the photograph shows the street as it appeared before it was paved. Travelers from Hagerstown, Maryland, entered Greencastle on this street, which was a portion of the main road to Carlisle. As important to the community then as they are today, trees lined the full length of many streets. (Courtesy of Evelyn Shinham Shatzer.)

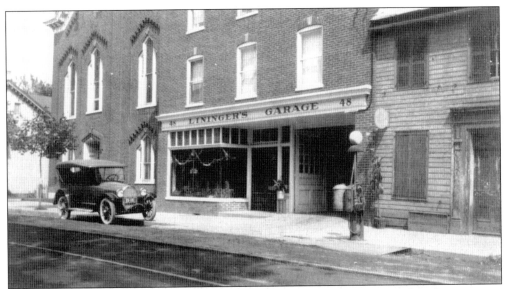

George P. Lininger built his second garage at 48 South Carlisle Street in 1915, with a two-story apartment above, where he lived. His first garage, on the northeast corner of Jefferson and Franklin Streets, was also the first garage in Greencastle when he opened it in March 1910. In 1910, Lininger was also licensed to sell the Grant ($495) and Metz ($475) automobiles. The car in the photograph was built between 1920 and 1922. (Courtesy of the Lilian S. Besore Memorial Library.)

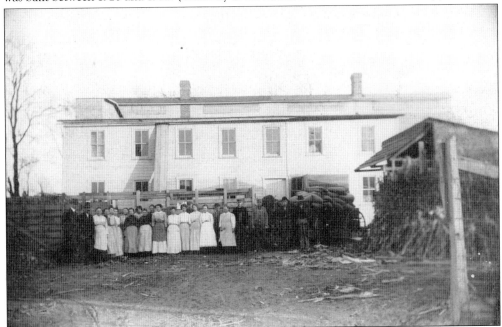

By the mid-1920s, over 12,000 acres of Antrim Township land were being used for fruit production, including apple, peach, and cherry orchards. This correlates with the fact that the number of agricultural-related industries began to increase in the Greencastle-Antrim area around that time. One such business was the four-kiln, apple-drying plant, owned by the Omwake Brothers, who had one of the largest apple orchards. In 1930, the fruit processing plant was sold to the Greencastle Packing Company. (Courtesy of the Lilian S. Besore Memorial Library.)

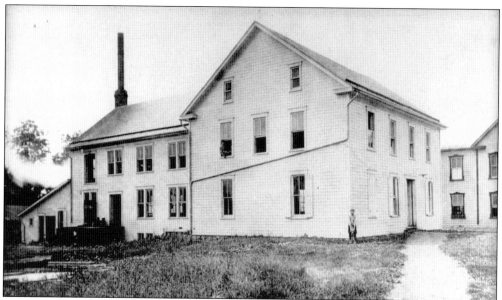

A peach evaporation (drying) plant was operated in the above building, located at the southeast corner of Dahlgren and South Carlisle Streets. Just after 1900, the Windsor Hosiery Mill opened operations in this building. During World War I, the mill operated on a wartime production basis and knitted socks for the soldiers. About 1930, Windsor moved its business into one of the former Crowell Manufacturing buildings that bordered South Washington Street and Cedar Lane. (Courtesy of Allison-Antrim Museum.)

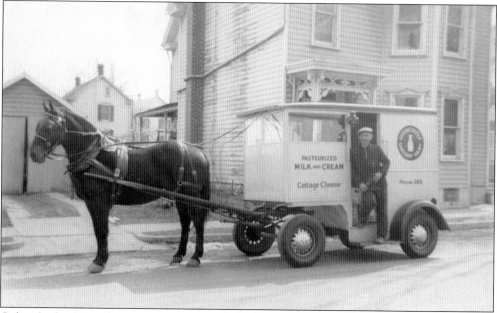

Colonel, the horse, was as well known around town as milkman Clinton "Doc" Minnich, who delivered the dairy products of the Greencastle Sanitary Dairy to homes throughout Greencastle. Colonel worked the route for so long that he knew every stop by memory. This presented problems when someone was out of town because he insisted on stopping anyway. (Courtesy of the Don and Ruth Coldsmith family.)

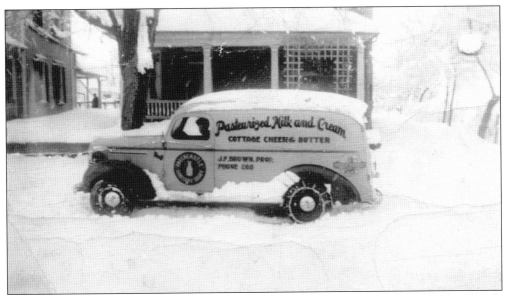

Barncord and Provard were the earliest commercial milk distributors during the first decade of the 20th century. Later Minnich became a partner. J. F. Brown eventually purchased the business and moved the creamery to North Elm Lane in 1925, at which time it was the leading supplier of milk in the community. The business was known as the Greencastle Sanitary Dairy. Driving the truck is Wilbur Mummert. (Courtesy of Paul Mummert.)

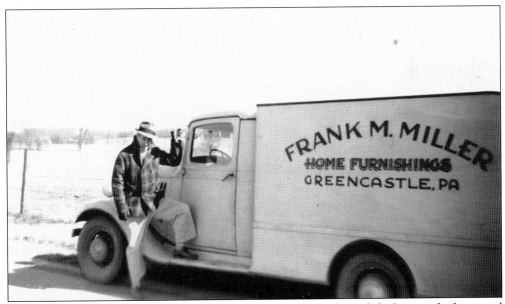

Frank Miller owned and operated a furniture store at 17 North Carlisle Street, which opened around 1910. There are still some who remember Miller and remember getting furniture from his establishment. In this photograph, Leroy Crist is standing by the 1931 Chevrolet truck, which was used as a furniture delivery truck by Miller. (Courtesy of Paul Mummert.)

In 1919, Greencastle Ice and Cold Storage of 255 North Carlisle Street opened one of the premier facilities of its kind in the Cumberland Valley. The operation utilized the most modern refrigeration technology of the time, which was developed by Frick Company in Waynesboro. Services included home delivery of manufactured ice, quick freezing and storage lockers for rent by home owners, and storage facilities for the county's large fruit industry. (Courtesy of Elizabeth Martin.)

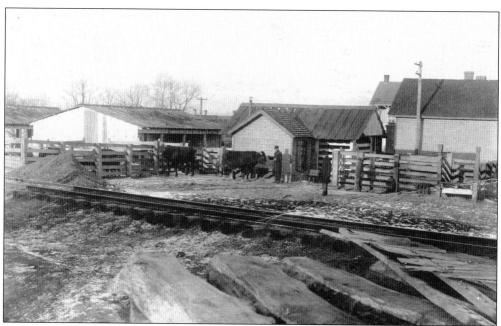

This *c.* 1935 photograph shows the Bruce Gordon stockyard, which was located on the east side of the railroad tracks in the 400 block of South Washington Street. The business was strategically located for convenient access for the transportation of livestock by railroad car. The Gordon stockyard preceded the present-day Greencastle Livestock Market, located east of Greencastle. (Courtesy of Lloyd "Sonny" Rowe Jr.)

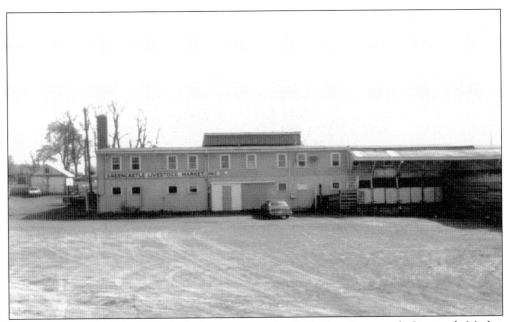

In 1870, there were three stock dealers in town. In 1941, the Greencastle Livestock Market opened for business on the east end of town at 720 Buchanan Trail East, bringing buyers from New York, New Jersey, and Maryland to purchase locally-raised livestock. Over the past 66 years, the business has been sold three times and each time modernization improvements have been made. (Courtesy of the Lilian S. Besore Memorial Library.)

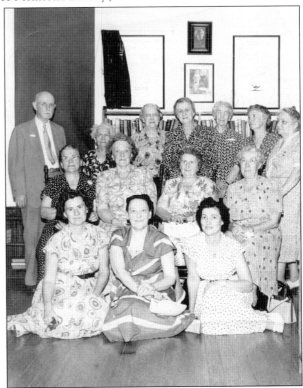

The Greencastle Circulating Library Association was formed in October 1900 and was housed in a room at 46 North Carlisle Street. An annual $1 fee allowed the subscriber to borrow books. In 1925, the library moved to 27 North Carlisle Street. There it remained until 1948 when it was transferred to the borough hall's top floor and became a public library. The library staff is seen here in the borough hall location. (Courtesy of the Lilian S. Besore Memorial Library.)

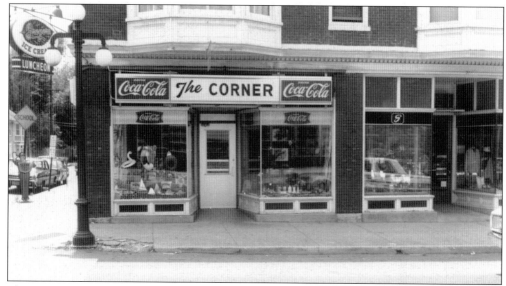

Pharmacist "Doc" Clark Faust opened the Corner drug store at 57 East Baltimore Street in the old Town Hall building. This drug store, with an ice-cream and soda fountain, was the students' favorite place to stop on their way home from school for the best cherry and vanilla Cokes and lemon blend in town. In the 1960s, the slogan was "Meet your friends at the Corner." (Courtesy of Elizabeth Martin.)

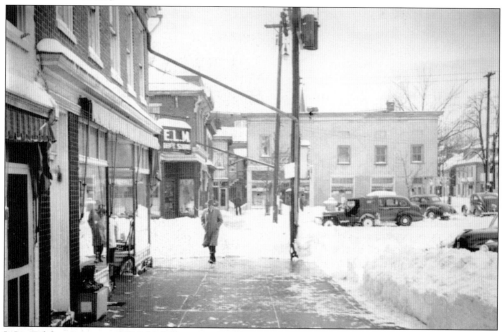

J. Ira Eshleman opened E. L. M. Department Store at 12 Center Square in 1941. E. L. M. stands for Eshleman, Lehman, and Martin. Maynard Metcalf managed the grocery store, which was on the left and was an off-shoot of the store on wheels, and John Oaks managed the hardware store on the right and the clothing store was on the second floor. Norman Martin and sons Lester and Harold took ownership of the shoe store and clothing store, respectively. (Courtesy of the E. L. M. Department Store.)

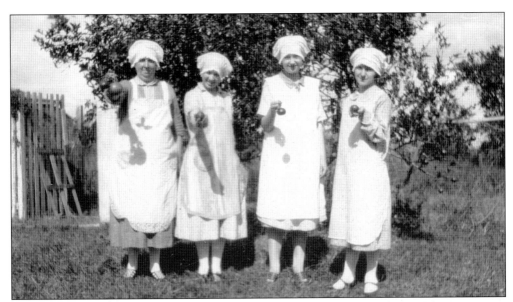

Four unknown ladies who worked at the Greencastle Packing Company show off the ripe tomato fruits of the season that were grown in the packing plant's own tomato garden, as seen in the right background. During the depression, local farmers grew vegetable crops for sale to the packing plant, which kept the farmers in business and in turn provided much needed employment, albeit seasonal. (Courtesy of Don and Ruth Coldsmith.)

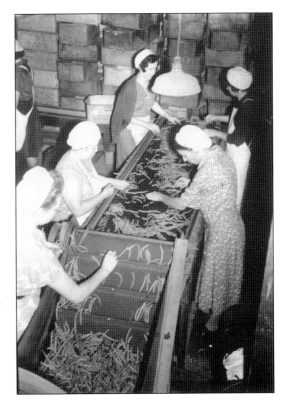

Tomatoes, peas, potatoes, green beans, and fruits were processed by the Greencastle Packing Company on North Washington Street. Once the canning of these green beans was finished, the cases would be taken to the North Washington Street warehouse without labels. Someone assigned to label the cases would do so according to the orders the company received, such as those from La Salle or Del Monte. Robert Schenekel was the owner. (Courtesy of the Lilian S. Besore Memorial Library.)

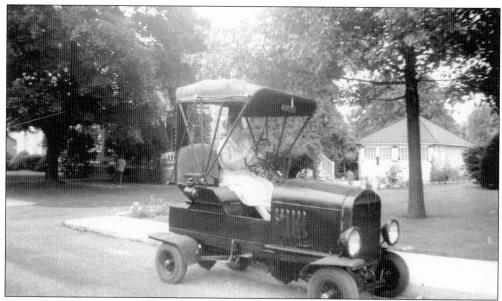

Although there is no photograph available of Harry Garling, he is well worth including. As a master mechanic, he is highly credited with keeping the Greencastle Packing Company operations in working order. Garling, also an inventor, made this car, the only one ever made in Greencastle. Mrs. Garling is driving the automobile in front of their home at 334 East Grant Street. (Courtesy of Lloyd "Sonny" Rowe Jr.)

Harold M. Zimmerman Sr. opened a new funeral home at 45 South Carlisle Street in 1948, when he returned to Greencastle after serving in India during World War II. Having tirelessly served the Greencastle-Antrim community for 42 years, the business was taken over by his son, H. Martin Zimmerman II, in 1990. (Courtesy of Jean K. Zimmerman.)

Charles "Whitey" Barkdoll bought the corner store of Preston and Martha Barnhart in 1949. Early on, customers often made daily trips to the self-service market because there were few homes with refrigerators. Many of today's prepackaged items came loose back then and were weighed for the customers. Barkdoll's Quality Market closed on August 21, 1993, after 44 years. It was the last corner store in Greencastle. (Courtesy of Elizabeth Martin.)

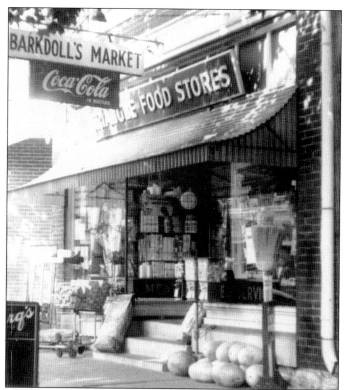

The congregation of the Bethel African Methodist Episcopal Church, at 227 South Carlisle Street, is likely gathered during an Old Home Week celebration. Internationally known artist and native of Greencastle, Walter Washington Smith painted the mural on the wall. As can be seen in the mural that depicts the crucifixion, his talents went beyond his well-known landscape paintings of Greencastle and Antrim Township. (Courtesy of John T. Conrad III.)

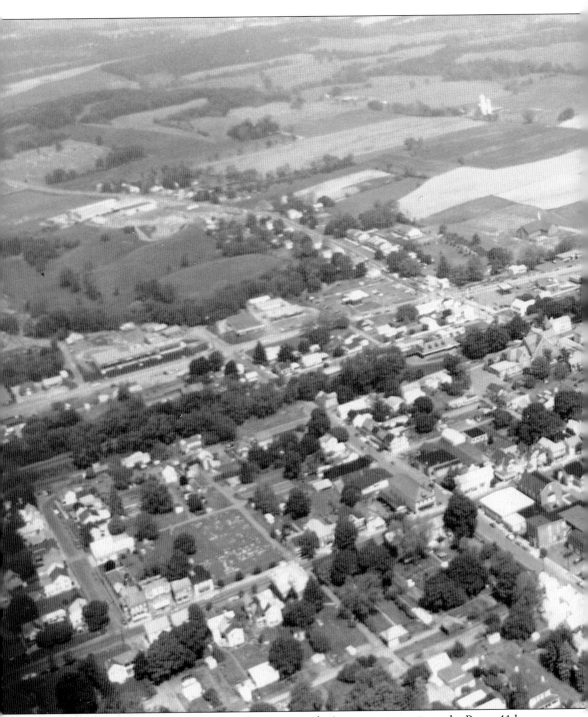

The 1950s brought many changes to the Greencastle-Antrim community—the Route 11 bypass (Antrim Way), the widening of Route 16, a new sewer system, housing developments, motels, and many new enterprises and businesses along Route 11. This c. 1985 aerial view of the western edge of Greencastle where it meets Antrim Township shows some of the development within the 30 years after Antrim Way north and south was built. At the intersection of Route 16 and

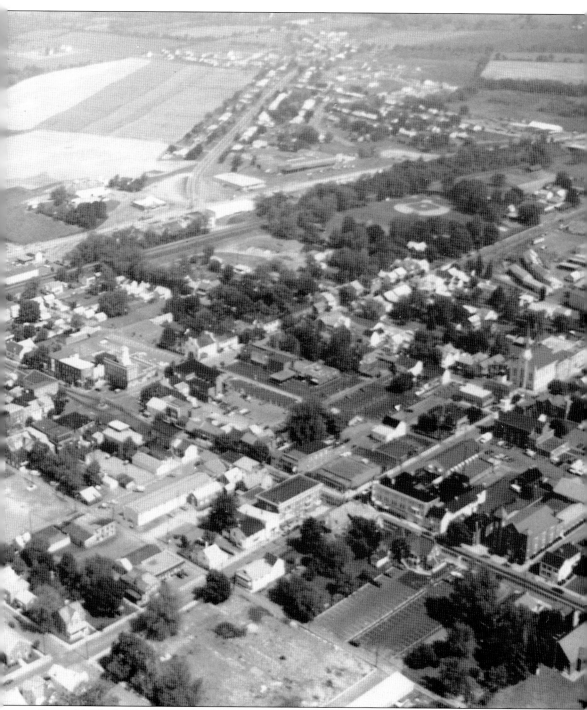

Route 11, Hardy's Restaurant has been built along with the little strip malls just south. On North Antrim Way, the little family-style restaurant, Sunnyway Diner, the first Sunnyway market building that is now a drug store, the 1969 Sunnyway market, the farming implement business and the houses built along Williamson Avenue are evident. (Courtesy of Kathleen Forney.)

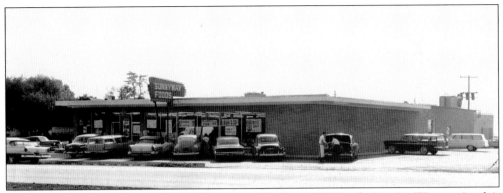

Aldine and Margaret Martin opened Sunnyway Foods at 200 North Antrim Way on April 1, 1955; it was remodeled and expanded five times. In 1965, their new store opened at 212 North Antrim Way but was destroyed by fire on December 7, 1969. The rebuilding began immediately. Prior to opening Sunnyway Foods, the Martins sold meats at farmers' markets in Hagerstown, Maryland, and Manheim and Hummelstown. (Courtesy of Sunnyway Food Market.)

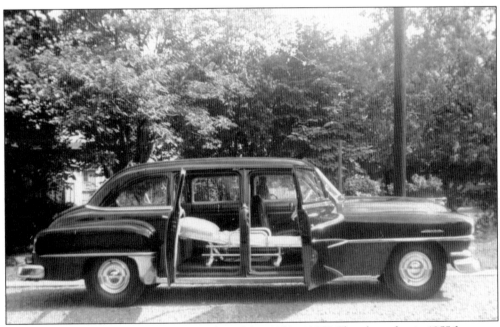

When Harold and Jean Zimmerman purchased this 1951 or 1952 Chrysler sedan in 1955 for use as an ambulance, they had already been providing free ambulance service to the Greencastle-Antrim community for seven years. The Zimmerman's ambulance service continued until 1967, at which time Rescue Hose Company No. 1 assumed the responsibility. The sedan was donated to the fire company by the Zimmermans. (Courtesy of Jean K. Zimmerman.)

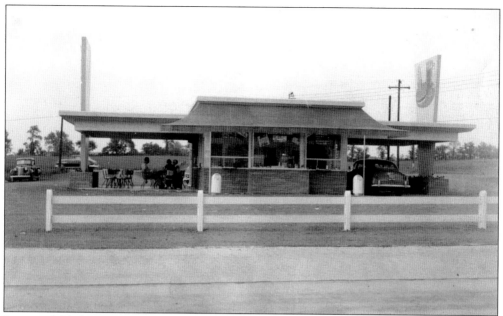

Leroy and Gladys McCrae opened Greenpoint Tastee-Freez, the "Home of the Big G," on May 1, 1955. It was strategically located on the point, where the Route 11 bypass split from old Route 11 on South Washington Street. Numerous high school students served customers who came in for burgers and shakes—one for each letter of the alphabet and more. Fire destroyed the business in May 1985. (Courtesy of Leroy and Gladys McCrae.)

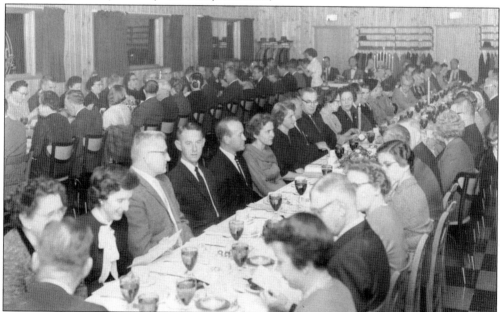

During the Great Depression, the board of trade ceased to exist. But in 1958, the Greencastle-Antrim Chamber of Commerce, a revival of the board of trade, began to promote the commercial, industrial, and civic interests of the community. Members of the chamber of commerce are seen here at the organization's first banquet in 1960, which became an annual event. Harold M. Zimmerman was the board's first president. (Courtesy of Allison-Antrim Museum.)

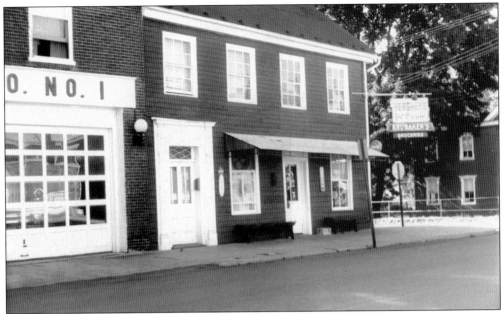

Bender Brubaker was the head chef for Harry W. McLaughlin in the McLaughlin Hotel's kitchen for a number of years, until the opportunity came along to purchase the small eatery at the northeast corner of South Carlisle and West Jefferson Streets. He opened a small eat-in area of three booths and was well known for his ham sandwiches. (Courtesy of Elizabeth Martin.)

Just like corner grocery stores, early gas pumps and then small gas stations were quite numerous throughout town. Preston Barnhart's Sunoco station was located on the property just east of 119 East Baltimore Street. There was a house on the property prior to this gas station being built. When the house was razed, the gas tanks were put in the cellar area. (Courtesy of Elizabeth Barnhart.)

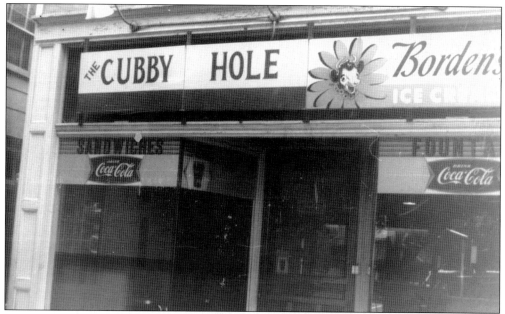

The history of the Cubby Hole at 20 Center Square likely goes back to the 1930s. Regardless of who owned the eatery, it was always a soup, sandwich, ice cream, and soda hangout for young people. When Steve Barna bought it about 1957 from Frank Mowen, he ran a contest to give the store a name. Fran Pearson's suggestion was the winning name—Cubby Hole. (Courtesy of Elizabeth Martin.)

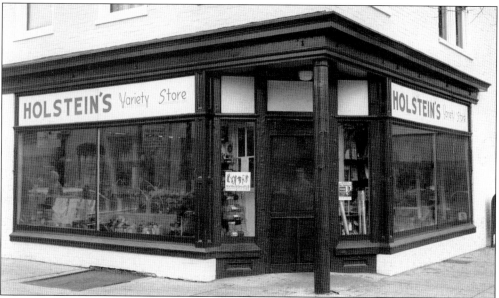

In 1974, thirty-four years after Branton and Carrie Holstein bought Jacob Trimmer's Five-and-Ten store at 3 Center Square, Holstein's Variety Store appeared as it does in this photograph. Its inventory was a sundry mix of Buster Brown children's clothing to small trinkets and toys that children could play with. This corner store has always been home to various stores. In 1863, Gen. George Pickett left a signed IOU for the items he confiscated from George W. Ziegler's store. (Courtesy of Allison-Antrim Museum.)

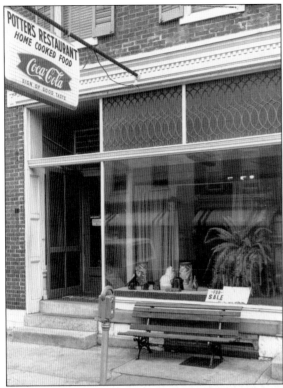

Charles "Strig" Potter and his wife, Martha, purchased the restaurant business at 24 East Baltimore Street, previously known as Buck's Restaurant, on June 4, 1942. Potter's Restaurant was best known for its home-cooked food, like fried chicken. About 1947, the Potters moved the restaurant to 14 South Carlisle Street. Potter's Restaurant served its patrons for 36 years until it closed on Easter Sunday in 1978. (Courtesy of Carla Kuykendall Wright.)

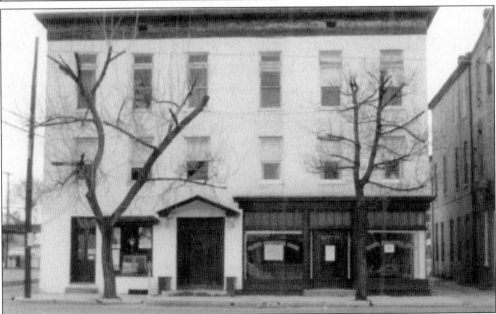

When Frank Miller decided to sell his furniture business, Leroy Crist, who worked for Miller, purchased the business and changed the name to Crist's Furniture Store. Both furniture stores operated out of the same storefront at 17 North Carlisle Street, located on the right in the above photograph. After Crist's death, Citizens Bank, now Susquehanna Bank, purchased the property around 1985 and razed the building for additional parking. (Courtesy of Robert Kugler.)

Three

BUSINESS AND INDUSTRY REVISITED

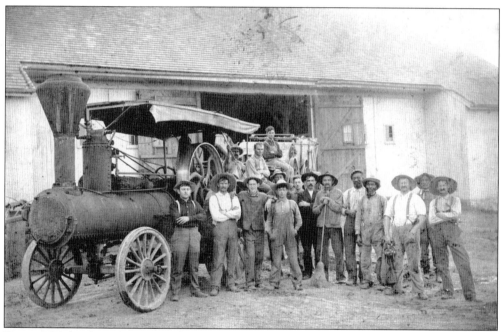

Howard Wishard owned about 700 acres of land between Kauffman's Station and Clay Hill, part of which included orchards, strawberry fields, and other agricultural interests. His work crew, standing here in the summertime next to the Geiser Peerless traction steam engine and a thresher, would be found in the wintertime operating a stone crusher that was powered by the same engine. Wishard also sold steam engines, threshers, and stone crushers. (Courtesy of Raymond Wishard.)

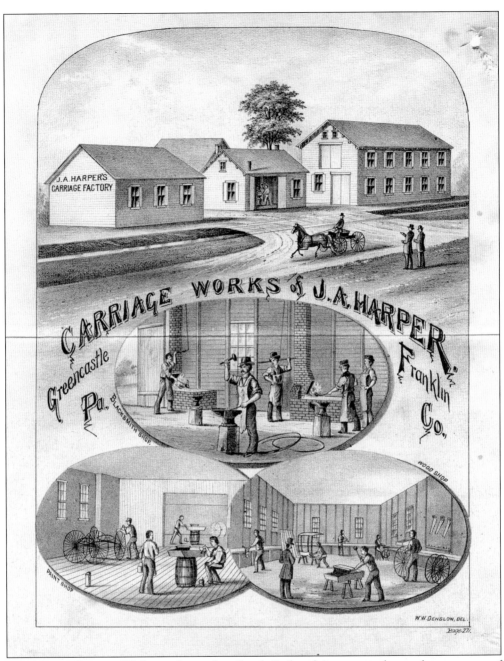

J. A. Harper Carriage Works was located on South Railroad Avenue on the southwest corner of today's South Carlisle and West Franklin Streets. Harper's company included a blacksmith shop, a wood shop, and a paint shop. In 1877, with a workforce of 10 men, Harper was able to produce and sell 53 new vehicles and made $2,800 on the repair of 75 used vehicles. Harper worked in the business of manufacturing carriages from the time he was 14 years of age. The buildings of his carriage works were constructed in 1874, at which time Harper immediately began his profitable business. (Courtesy of Kenneth B. and Bonnie A. Shockey.)

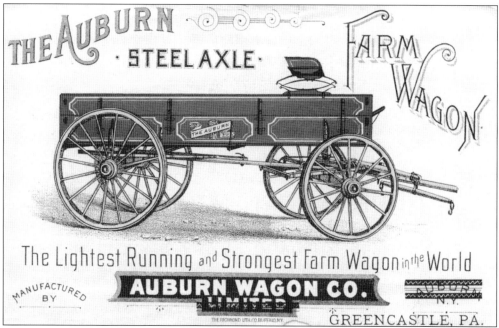

A well-known farm wagon and carriage company from New York State opened a plant in Greencastle in 1893. The Auburn Wagon Works rented space from Jacob B. Crowell at the south end of town. The company employed about 150 men, but found a better facility in Martinsburg, West Virginia, and left Greencastle in 1896. This image is from a surviving piece of advertising ephemera from the Greencastle period. (Courtesy of Mike Rhorer.)

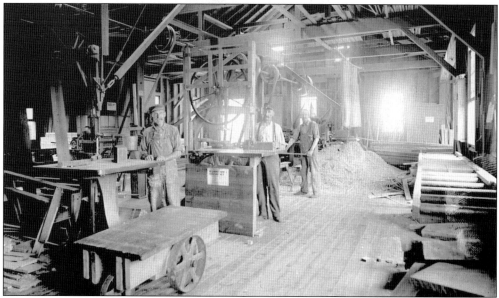

The interior of the wood planning mill, of the business known as Omwake Brothers, is shown in this photograph from about 1915. The haze in the center of the picture is not from incorrectly exposing the photograph, but is the sawdust hanging in the air from the milling process. One can literally step back into time by visiting this planning mill, which is still operating. (Courtesy of Jean Oliver Reymer and Robert C. Reymer Jr.)

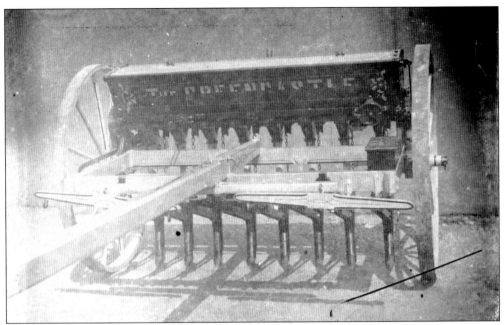

Jacob Crowell was best known for producing the Willoughby Grain Drill. As improvements were made, the drill's name changed to "the Greencastle." It was made with eight or nine boots (hoes) which plowed the rows and planted the seeds at the same time. A force-fed attachment also fertilized as the seeds were planted. An old photograph has survived of one of the original drills. (Courtesy of the Lilian S. Besore Memorial Library.)

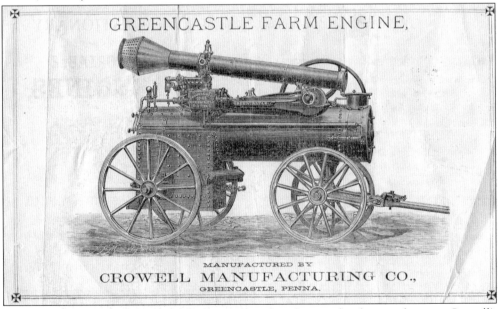

GREENCASTLE FARM ENGINE,

MANUFACTURED BY
CROWELL MANUFACTURING CO.,
GREENCASTLE, PENNA.

Crowell Manufacturing was always on the cutting edge of new technology, and so were Crowell's steam engines. This pen-and-ink lithographic illustration is from an advertising brochure of the time period for the Greencastle Farm Engine. It was a portable engine that could be transported to wherever a job needed to be done. It provided the power to run sawmills, stone crushers, pumps, threshers, and so on. (Courtesy of Mike Rhorer.)

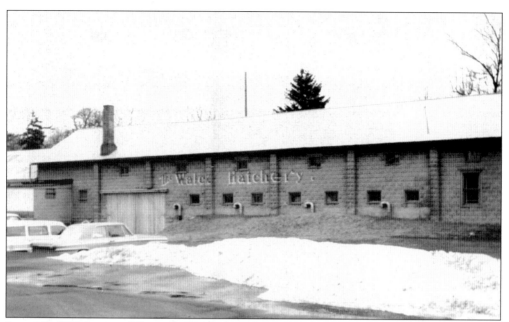

Lester. R. Walck, son of Henry S. Walck, built his first hatchery in 1908, near the grain cradle shop in the Canebrake area. This hatchery burned in 1925. He was one of the first in the country to establish such a business; one of the most modern of its time. In 1925, he built a second hatchery in Greencastle and was in the hatchery business until his death in 1942. (Courtesy of Elizabeth Martin.)

The stationary Flinchbaugh buck saw, as seen in this catalog illustration, was made for home or farm use to cut wood. The 24-inch-diameter blade was belt driven and could be powered by either a steam or gasoline engine. Allison-Antrim Museum has a "Made in Greencastle" Flinchbaugh buck saw in its collections. Until July 2006, it had been used on a regular basis. (Courtesy of Allison-Antrim Museum.)

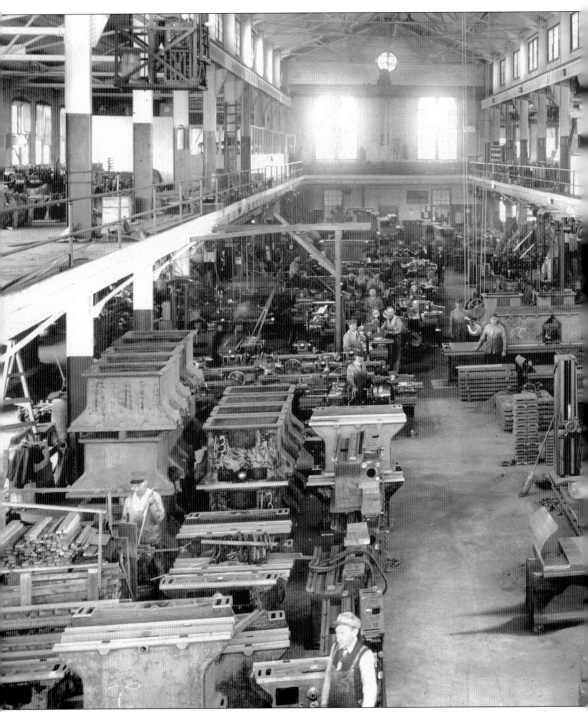

Frederick T. Flinchbaugh of York came to Greencastle in 1913 to see if there were enough investors who would be interested in building a manufacturing complex for his gasoline engine business. The Flinchbaugh Manufacturing Company in Greencastle opened for business in 1914. Only in operation a little over a year, the company filed for bankruptcy in August 1915. There is little information on the reason why, but local legend says that Flinchbaugh had a disagreement

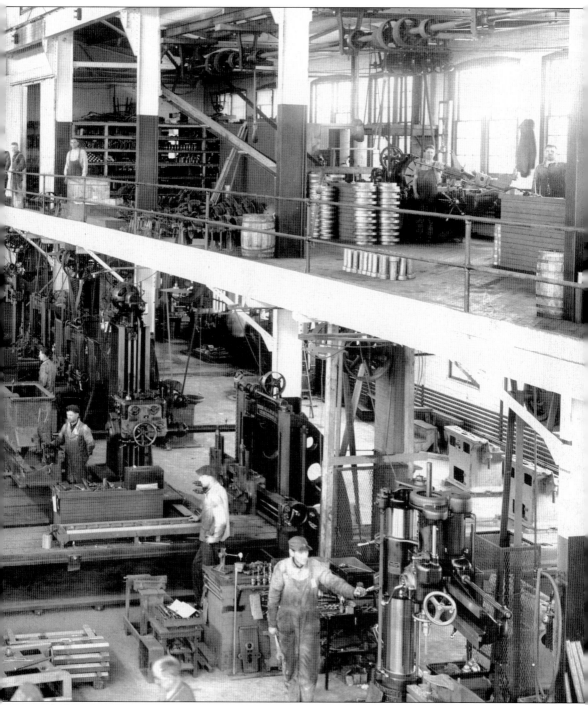

with the investors of the company. On November 10, 1915, Landis Tool Company of Waynesboro purchased the facility for $42,500. Seen here, from the upper level, are the machine shop operations of the Landis Tool Company's plant in Greencastle. This building was the largest of the buildings in the complex. (Courtesy of the Lilian S. Besore Memorial Library.)

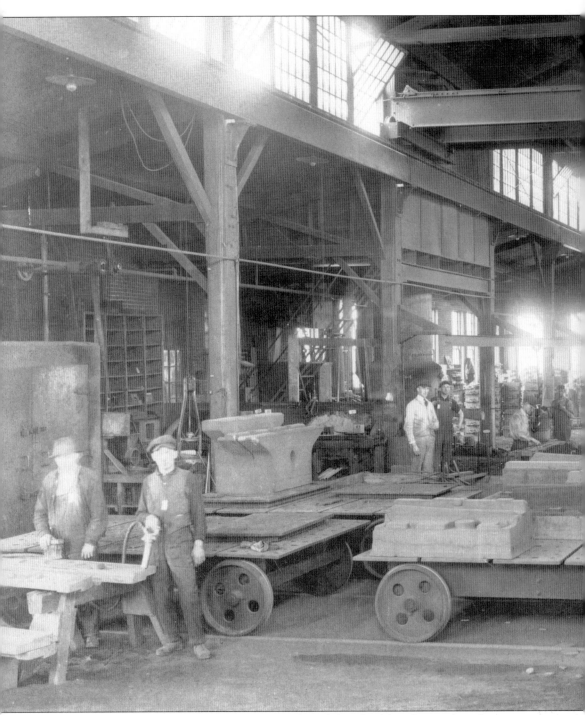

At the time when Landis Tool Company purchased the Flinchbaugh complex, there were not enough machine tool operators in Waynesboro to keep up with the incoming orders because men were leaving for higher wages being paid at other companies for war-order work. When the Flinchbaugh Company closed, 100–150 Greencastle men were left unemployed. It was the perfect solution for the tool company's dilemma. The company's small universal grinder was produced at

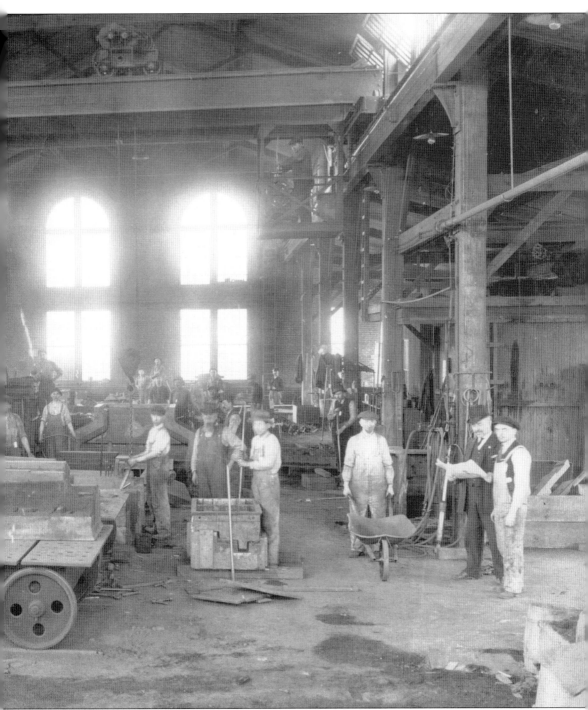

the Greencastle plant. Landis Tool Company owned the Flinchbaugh complex from 1915 to 1943, when production and operations were stopped. At this point, the company decided to downsize by consolidating their operations in the Waynesboro plant complex. The tool company's employees, seen here in a very rare photograph, worked in the foundry building, which was the second largest building in the complex. (Courtesy of the Lilian S. Besore Memorial Library.)

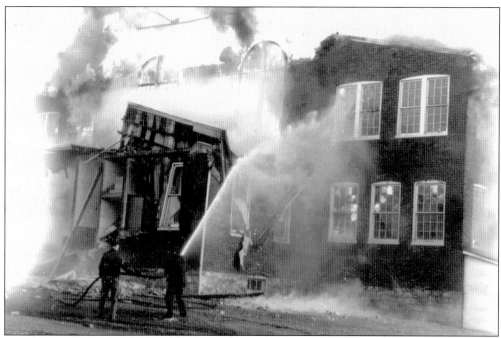

A. R. Warner and Son purchased the Flinchbaugh complex from Landis Tool Company in 1944. Used as a warehouse, space was leased to the War Food Administration and the Bethlehem-Fairchild Shipyard Company. Total destruction of the building and its contents occurred on March 8, 1945, when a fire began. Another building was built on the site by 1949. (Courtesy of the Rescue Hose Company No. 1.)

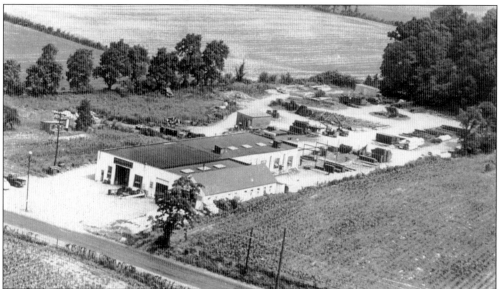

This photograph shows the early plant of Grove Manufacturing Company, prior to the April 28, 1960, fire when the facility was still surrounded on three sides by corn fields. The superb quality and performance of the Grove crane line resulted in worldwide sales and phenomenal growth of the company. Although Manitowoc Crane Group owns the Grove crane line, Grove cranes are still produced at the Shady Grove facility. (Courtesy of Manitowoc Crane Group.)

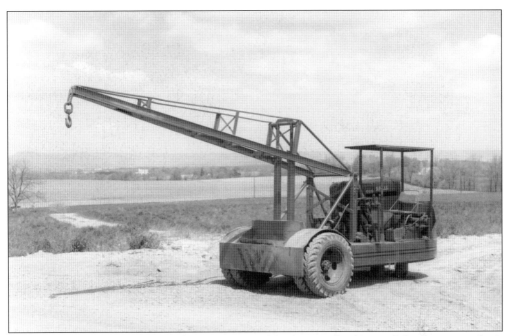

John L. and Dwight Grove were the inventors and engineers who designed the first cranes built by their company. The cranes were birthed out of a need to lift and move the steel plates and beams that they used in the construction of their farm wagons. This is one of the improved early cranes, which used two cylinders to lift the I-beam boom. (Courtesy of John L. Grove.)

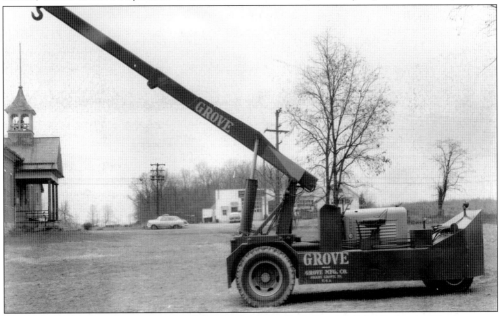

To protect his crane design features, John L. Grove applied for a Mobile Hydraulic Crane patent in 1956. The hook on this second-generation crane is still fixed to the end of the boom, but the boom has two cylinders: one for telescoping and one for lifting and lowering the load line and hook. The photograph was taken across Route 16 with the plant in the background. (Courtesy of Manitowoc Crane Group.)

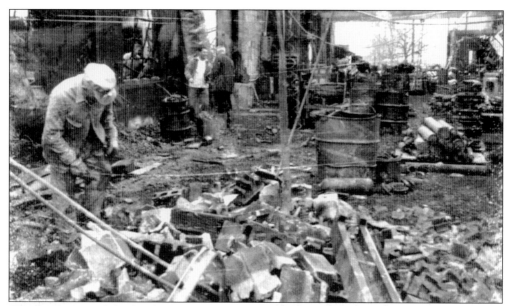

The devastation of the fire that occurred on April 28, 1960, at Grove Manufacturing Company is quite evident in this photograph. Five fire companies responded to the alarm, but the building was completely engulfed in flames, with an estimated loss of over $250,000. In spite of the great loss, John L. and Dwight Grove, Wayne Nicarry, and the investors decided to rebuild. Within two months a block building was erected. (Courtesy of Lee Grove.)

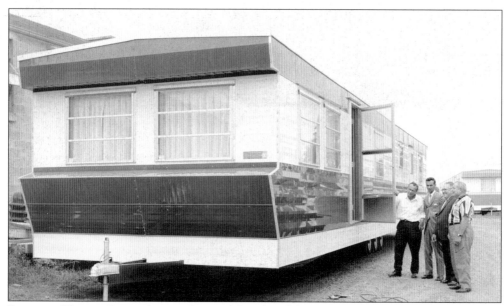

Benjamin Thomas Sr. was the president and founder of the Greencastle Coach Company, which was located at 1080 Hykes Road. Until 1972, the company produced a line of mobile homes known as the *Homemaker*, which were well known in the four-state region for their quality. The company held several patents relative to the strength of the mobile home's framework. Pictured from left to right are Don Fortney, unidentified, unidentified, and Lawrence Zeger. (Courtesy of Benjamin Thomas Jr.)

Four

HIGHWAYS AND BYWAYS

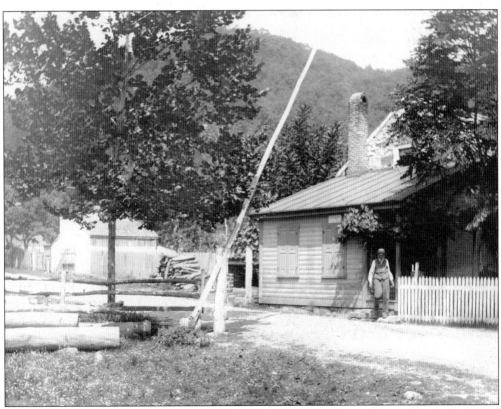

Located east of the five-arch limestone bridge that spanned the Conococheague Creek, the "Dale" tollgate stop and the gatekeeper's house once stood along the Waynesboro-Greencastle-Mercersburg Turnpike. The 42-mile turnpike remained a toll road until February 7, 1918, when the Commonwealth of Pennsylvania purchased it from the stockholders at the sum of $52,352 and assumed the costs of maintenance and construction. The long wooden arm is called a pike, ergo turnpike. (Courtesy of Allison-Antrim Museum.)

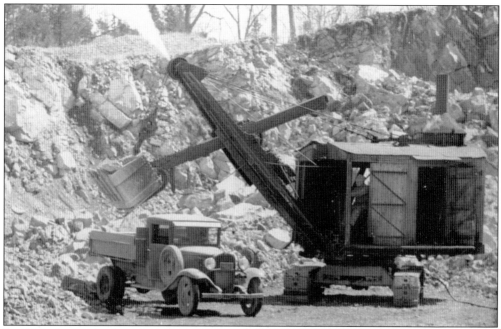

In 1908, the Cumberland Valley Railroad began construction of the highline one block west of town along Jefferson Street. A tremendous amount of fill had to be brought in to create the bank on which some sections of the tracks would run. An early steam shovel and pickup truck are seen here loading stone and dirt into the very small truck. (Courtesy of Joyce Pensinger Berger.)

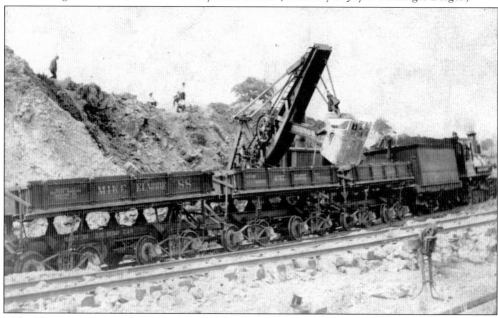

Mike Elmore was one of the contractors for the construction of the highline. His equipment included side-dumping cars manufactured by Western Wheeled Scraper Company in Aurora, Illinois. As the shovel operator works on moving tons of dirt, onlookers on the ridge of the bank have a bird's-eye view. Another worker is climbing onto the larger, box-shaped car, which is behind the steam engine. (Courtesy of John T. Conrad III.)

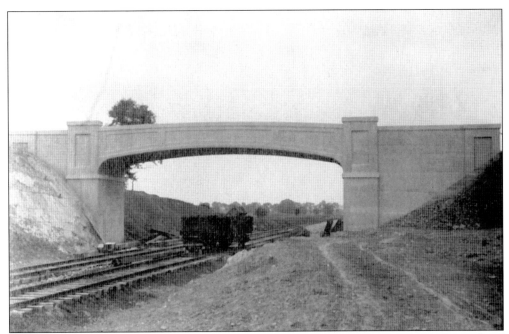

When finished at the end of the 1908 Cumberland Valley Railroad highline project, the steel and concrete bridge on Walter Avenue at the intersections of Route 11 north on the left and North Carlisle Street spanned 600 feet. The center clearance for trains was 22½ feet. This bridge is now known as the Edwin C. Bittner Memorial Bridge. (Courtesy of Allison-Antrim Museum.)

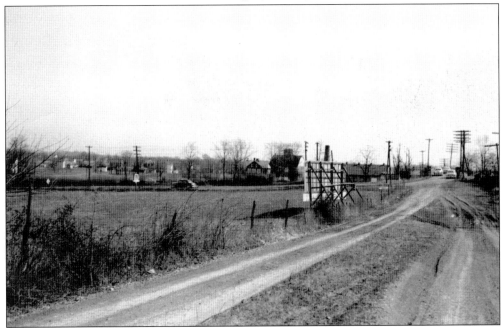

This is a rare view, looking east from West Walter Avenue toward the railroad overpass bridge at Route 11 north. At this time, West Walter Avenue was not yet paved. The back of a billboard was angled toward southbound cars at the corner, which is now occupied by Meyer's Implements at 400 North Antrim Way. (Courtesy of Edwin C. Bittner.)

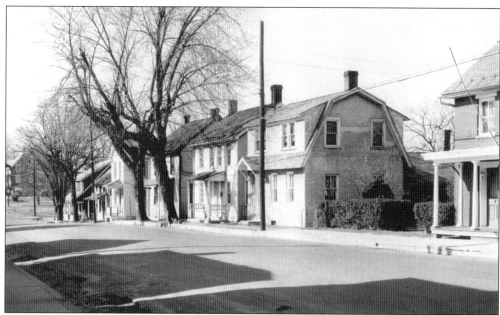

On West Baltimore Street, from the left, houses six through nine were demolished in 1954 to make way for the Route 11 bypass. Route 11 and a Sheetz store now replace those four homes. The third house from the left, a c. 1800 log home, was dismantled a number of years ago. In May 2006, the second and fourth buildings from the left were razed to make room for a CVS drug store. (Courtesy of Evelyn Pensinger.)

Looking north, the West Baltimore Street and West Madison Street homes, which sat in the path of the new Route 11 bypass, have been razed since this photograph was taken. The intersection toward the vanishing point is Madison Street. Before Route 11 was there, Williamson Road, near the top of the hill on the left, exited onto Carl Avenue, in front of the white house. (Courtesy of Edwin C. Bittner.)

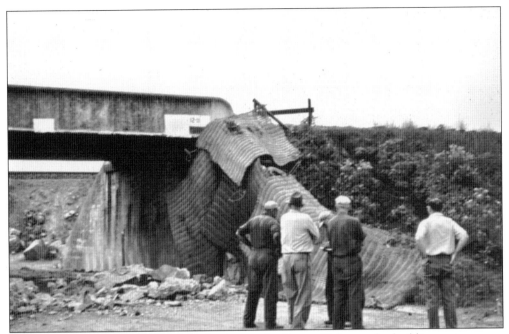

At the southern end of town, work began on the Route 11 bypass by building a temporary railroad bypass, which can be seen to the west, under the bridge. The demolition of the old highline bridge began by the contractors setting charges. The steel mesh blankets were placed over the area to buffer the explosion of flying concrete. (Courtesy of Ray Mowen.)

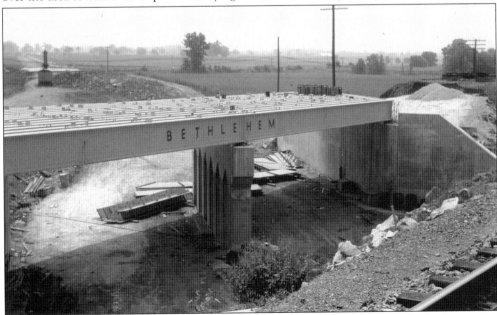

Looking south, the first path of the southern part of the bypass, leading from the bridge, can be seen winding toward what would become the point at South Washington Street and Route 11, coming from Hagerstown, Maryland. The forms have not yet been built for the concrete encasement of the Bethlehem Steel I-beams, prior to the final part of the project of laying the rails. (Courtesy of Ray Mowen.)

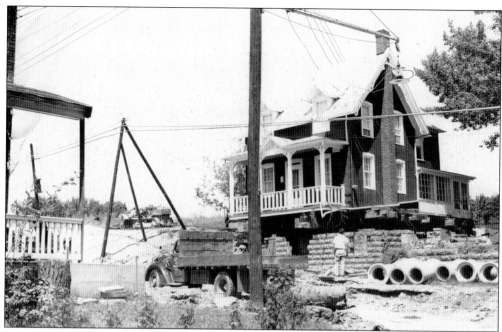

It appears the house is levitating, but it is actually a house raising at 343 West Baltimore Street. This home had to be moved back about 40 feet to provide room for the widening of Route 16. The preparation involved below-grade excavation, uniformly raising the house up off the foundation, and, finally, moving the house. Amazingly the Bittner family lived in the house through the process. (Courtesy of Edwin C. Bittner.)

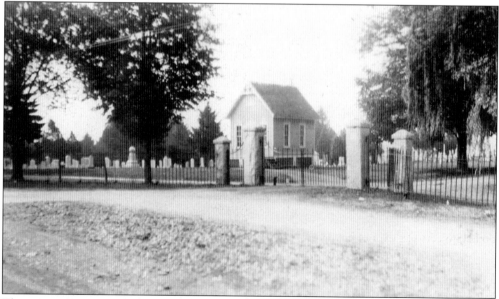

This view of Cedar Hill Cemetery, which was established in 1870, looks south from the north side of Route 16. The route was widened in 1955. The small building was used as a chapel and service area. The photograph was taken prior to 1932 because the chapel was moved to the southern boundary of the cemetery at that time, when the current memorial to veterans was erected on that site. (Courtesy of Lloyd "Sonny" Rowe Jr.)

The northeastern entrance to the Cedar Hill Cemetery, south of Route 16, is seen here in August 1955 just prior to the widening of the highway. The beautiful granite pillars at all the main entrances were not set back in place after the construction project was completed. To soften the hills and gullies of the road, the state raised the roadbed at the intersection of Grant Shook Road. (Courtesy of Zimmerman Funeral Home.)

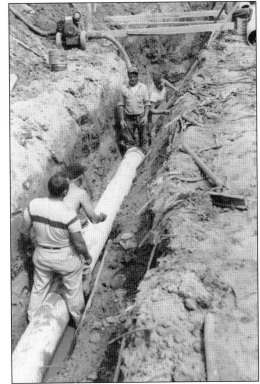

Some projects just cannot be completed without manpower. By 1957, residents of Greencastle and those passing through must have been very tired of all the construction projects. In 1954, the Route 11 bypass was begun, and the following year the widening of Route 16 started. In mid-1957, the digging of trenches for laying new sewer and water lines commenced. (Courtesy of Edwin C. Bittner.)

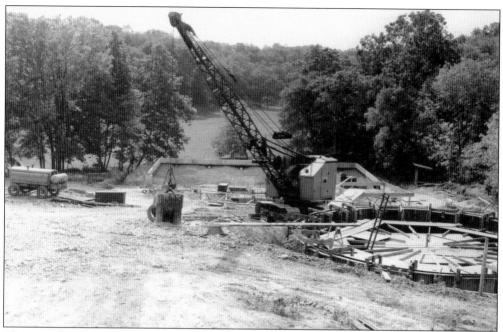

The new borough sewage system required a modern treatment plant. Looking west, this September 1957 photograph shows part of the construction process at the site, located at 10339 Grant Shook Road. With the grappling hook in place, the c. 1955 crane is about to lift another section of the system's huge pipes into place. (Courtesy of Edwin C. Bittner.)

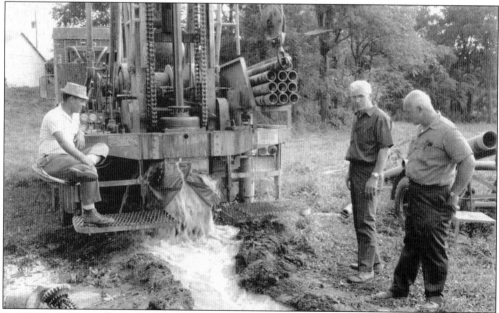

In 1966, the borough needed to find an additional source of water to meet the needs of the growing town. This photograph shows the drilling process on what is now the Borough of Greencastle's farm, located off Long Lane. The output of 350 gallons per minute met the borough's requirements for a new well. John T. Conrad II is on the right. The other two men are unidentified. (Courtesy of Edwin C. Bittner.)

Five

V IS FOR VICTORY, VALOR, AND PEACE

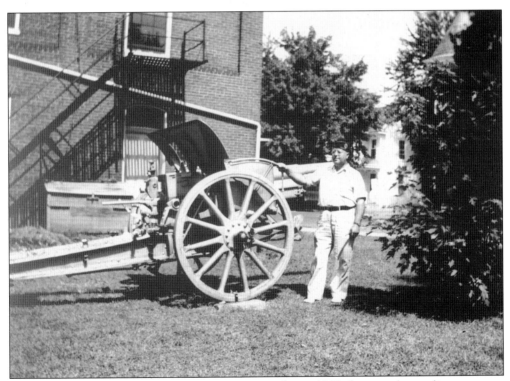

World War I veteran Arthur James Fair is seen in this *c.* 1945 photograph standing next to a World War I cannon, which was displayed on the grounds of the borough office. The cannon was moved to 254 South Carlisle Street when the new American Legion Post 373 building was constructed in 1972. (Courtesy of Lloyd "Sonny" Rowe Jr.)

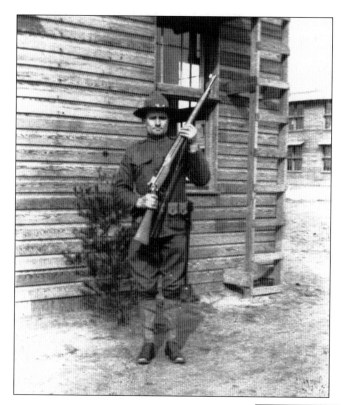

Thomas Atherton is shown here while training at Fort George G. Meade during World War I. Atherton contracted a fever and was never shipped out for active service during the war. Built on 19,000 acres of land west of Odenton, Maryland, the fort was opened in 1917 under the name Camp Admiral. (Courtesy of Oliver Goetz.)

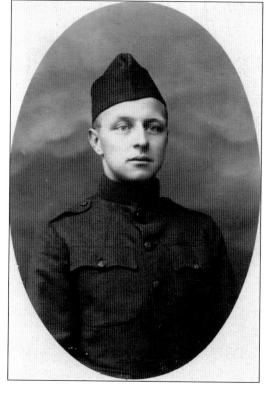

Walter Binkley was from State Line and served in World War I from 1917 to 1918. Not much is known about his life at that time. In addition to his photograph, Allison-Antrim Museum's collection has several of Binkley's World War I army issued belongings, including a jacket, trousers, two sweaters, three kepi hats, a GI wallet, an English/German dictionary, and his U.S. World War I grave marker. (Courtesy Allison-Antrim Museum.)

This photograph of Frank Diehl (left) and his brother George was taken while they were in Germany during World War I. Both men were drafted as infantrymen and served as messengers. They were raised in Antrim Township, but after the war they settled in Lenark, Illinois, and Mercersburg, Pennsylvania, respectively. (Courtesy of William A. Diehl.)

Arthur James Fair of Greencastle was born on June 14, 1896, and died on October 19, 1967. The items in the Fair collection (minus boots, helmet, and gas mask) represent an almost entire issue of clothing for a World War I serviceman. A caduceus insignia pin indicates that Fair was in the medical corps. He is buried in the Cedar Hill Cemetery and the United States flag that draped Fair's casket is part of the collection. (Courtesy Allison-Antrim Museum.)

On March 12, 1942, the defense council moved the local observation air raid post to a field opposite 329 South Ridge Avenue. Hundreds of volunteers manned the post 24 hours a day; each individual was certified for the U.S. Army's Aircraft Identifying Service. All planes flying overhead were counted, identified, and recorded. This duty continued until the war ended. The man in the photograph is W. Harry Gillan. (Courtesy of Lloyd "Sonny" Rowe Jr.)

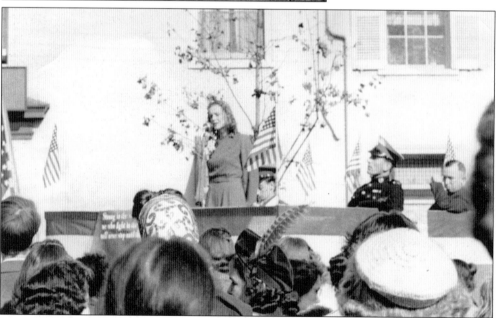

Jarvis Henson took this photograph when Hollywood celebrity Gloria Stuart came to town in 1942 for a war bond drive. The quote on the banner by Vice Pres. Harry Wallace says, "Strong in the strength of the Lord, we who fight in the people's cause will never stop until that cause is won." Eight bond drives in Greencastle-Antrim, between April 23, 1942, and December 13, 1945, raised about $1,247,500. (Courtesy of Frank and Louise Mowen.)

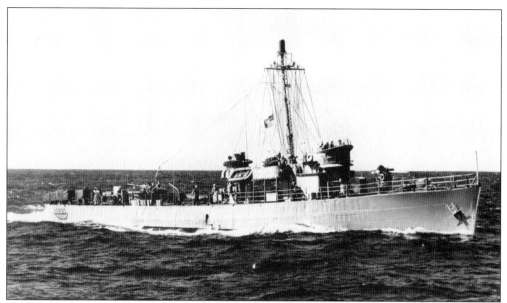

The USS *Greencastle (PC-119)* was a U.S. Navy patrol boat, which was named after Greencastle, Pennsylvania, and Greencastle, Indiana. It was commissioned on December 15, 1942, and was assigned to the South Pacific in Australia and New Guinea. It received five battle stars for heroic service during World War II. The USS *Greencastle* was decommissioned on January 9, 1947, renamed *Greencastle* in February 1956, and was sold for scrap on July 1, 1958. (Courtesy of Frank Ervin.)

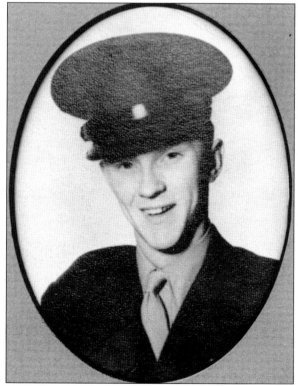

Pvt. Omar David (Dave) Witmer Jr. graduated from Greencastle-Antrim High School in 1965. He enlisted in the Marine Corps and was stationed at the Khe Sanh Marine Combat Base in Quang Tri, South Vietnam. Witmer became Greencastle-Antrim's first casualty of the Vietnam War on September 17, 1967, when he was killed in a nonhostile accident. Witmer's name is engraved on the Vietnam Memorial Wall on panel 26E, line 86. (Courtesy of Greencastle American Legion Post 373.)

Spec. Joseph (Joe) Robert Beck Jr. rose to the rank of SP5-E5 in the army's special forces unit. Beck had only been in South Vietnam for one and a half months when he was killed on October 26, 1967, in a helicopter crash caused by hostile fire in Phuoc Long. Beck's name is engraved on the Vietnam Memorial Wall on panel 28E, line 72. (Courtesy of Greencastle American Legion Post 373.)

Pvt. Thomas Ray "Cookie" Cook Jr. was an outstanding drummer, a Civil War buff, and he graduated in 1966. While in the army's 101st Airborne Division, he played the drums at a service club, and everyone stopped to listen. Cookie was killed July 26, 1968, at the battle of Cu Chi while trying to save three wounded comrades. Cook's name is engraved on the Vietnam Memorial Wall on panel 50W, line 12. (Courtesy of Greencastle American Legion Post 373.)

Pvt. Randy Truman Kendle enlisted in the army and was only 18 years old when he died on May 12, 1969, from burns received during hostile fire in battle in Quang Tin in South Vietnam. He died barely three months after his tour of duty began on March 16, 1969. Kendle's name is engraved on the Vietnam Memorial Wall on panel 25W, line 76. (Courtesy of Greencastle American Legion Post 373.)

Spec. Robert Wayne Bowman graduated from Greencastle-Antrim High School in 1963. After joining the military service, he was assigned to the army's 101st Airborne Division. Bowman's Vietnam tour of duty began on October 26, 1968. He was Greencastle-Antrim's last Vietnam War casualty when he was killed in a nonhostile helicopter crash in Thua Thien on March 15, 1969. Bowman's name is engraved on the Vietnam Memorial Wall on panel 29W, line 43. (Courtesy of Greencastle American Legion Post 373.)

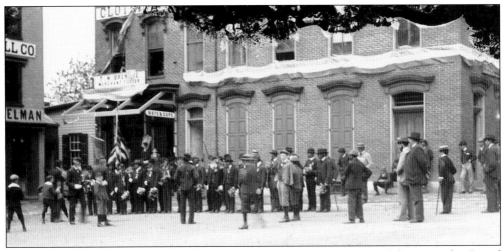

Greencastle-Antrim has always honored its veterans of war on one special day since the Grand Army of the Republic Corporal Rihl Post No. 438 held the first memorial ceremony on May 30, 1884. These aging Civil War veterans are forming rank in the northwest corner of the square prior to marching out of town to Cedar Hill Cemetery. (Courtesy of the Lilian S. Besore Memorial Library.)

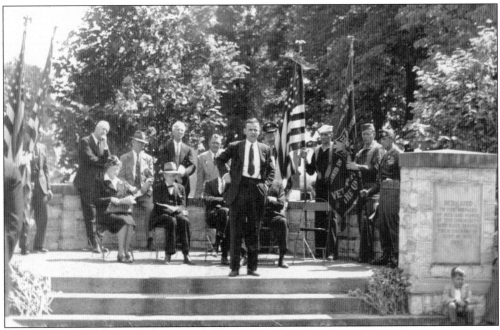

In 1932 at the Cedar Hill Cemetery, this very simple, all-encompassing stone monument was "dedicated to the memory of men and women of this community who have served their country in time of war." Since that time, hundreds of men and women have been honored and remembered from five additional wars during 75 more Memorial Day ceremonies. Each generation must remember, lest everyone forget. (Courtesy of Allison-Antrim Museum.)

Six

THE IRWINS, SNIVELYS, AND ZIEGLERS

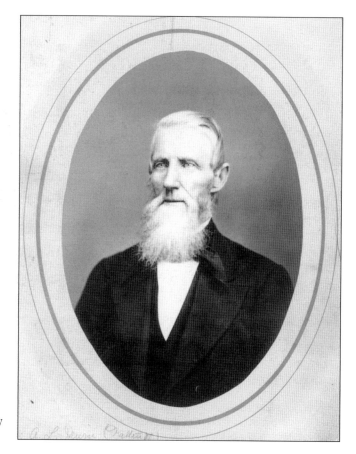

Alexander L. Irwin was born September 15, 1811, in County Lanarkshire, Northern Ireland. He moved to Greencastle in 1855 and established Greencastle's first hardware store in a building at 14 Center Square. Irwin's prosperous business allowed him to retire early and not have to work for a number of years. Irwin was a prominent citizen of the community, an underwriter of the Williamsport Turnpike, and a Democrat. During the Civil War, he loaned his "hall" for fund-raisers. Irwin died on September 22, 1890. (Courtesy of Daniel F. Wolford.)

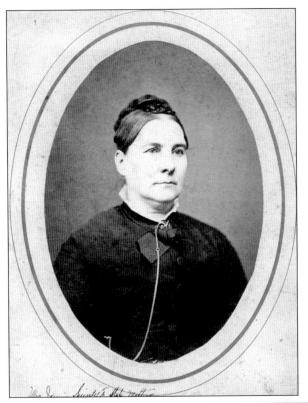

Martha J. Means was Alexander L. Irwin's second wife. They had five children, none of who married. Means was born in 1820 and died March 23, 1905, and she is buried in the Irwin family plot in Cedar Grove Cemetery in Chambersburg. In 1860, the Irwin's built the stately, Greek Revival–period, two-story brick home at 365 South Ridge Avenue, which is now owned by Allison-Antrim Museum. (Courtesy of Daniel F. Wolford.)

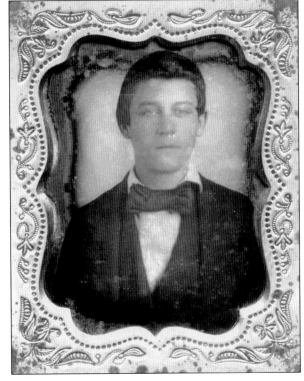

James Montgomery Irwin, eldest son of Alexander L. Irwin and his first wife, Sara Jane Montgomery, was admitted to the Franklin County Bar Association on January 23, 1863. He was an active member of the Franklin County Democratic Committee. After the Civil War, he went west with his sister and brother-in-law. He died April 28, 1887, in Maryville, North Dakota, after having been one of the early settlers in that area. (Courtesy of Daniel F. Wolford.)

Alfred L. Irwin was the third son of Alexander L. Irwin and his first wife, Sara J. Montgomery. He went west with his sister Jane and her husband, Scott Snively, after the Civil War and married out there. He was known by the family as Alford or Lewis, which is possibly a clue as to what his father's middle name may have been. (Courtesy of Daniel F. Wolford.)

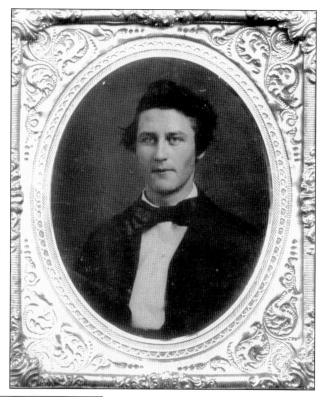

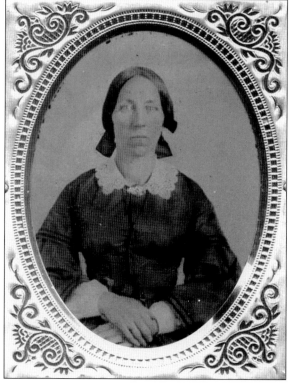

Jane "Jennie" Irwin, Alexander L. Irwin's only daughter from his first marriage, was Irwin's only child known to bear children. She married Scott Snively on January 23, 1868, in the Greencastle Presbyterian Church, after which they moved west. Jane may have only returned to Greencastle upon her stepmother's death. The Irwin and Snively photographs came home to Greencastle-Antrim from Omaha, Nebraska, courtesy of Daniel Wolford, great-great-great-grandson of the Snively's. (Courtesy of Daniel F. Wolford.)

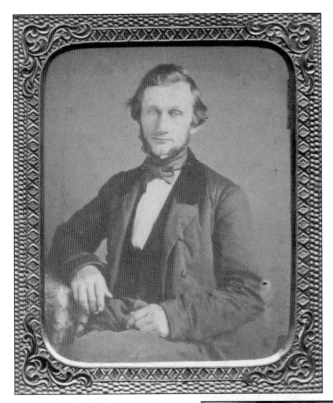

It is likely that no one living in Greencastle-Antrim has ever seen this photograph of Melchi Snively who was born on January 9, 1816, and died October 1, 1897. He founded Shady Grove in 1848, opened its first store, and was Shady Grove's first postmaster. He was a school director for Antrim Township, a Republican, and was a charter member and director of the First National Bank. (Courtesy of Daniel F. Wolford.)

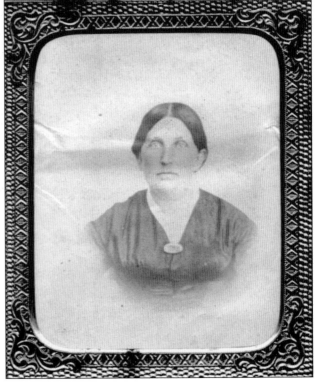

Elizabeth Newcomer married Melchi Snively on August 8, 1837. They had five children: Frederick, William, George, Scott, and Virginia. Frederick, a prominent businessman, lost his life in the Washington Hotel fire in Hagerstown, Maryland. George and Scott both served gallantly in the Civil War. Elizabeth passed away on August 9, 1861. (Courtesy of Daniel F. Wolford.)

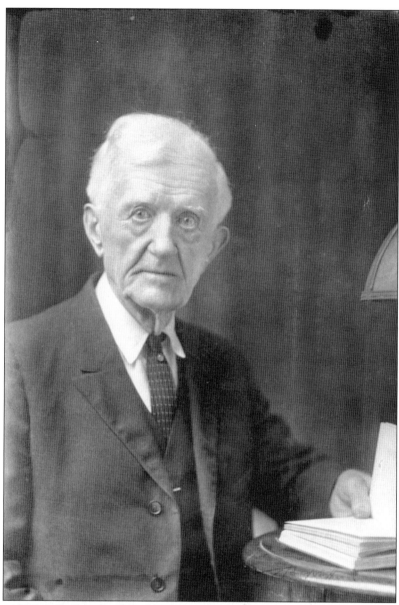

Corp. Scott Kennedy Snively, son of Melchi and Elizabeth, was born on September 9, 1845, and died on July 24, 1931. He had an illustrious tour of duty during the Civil War and enlisted twice—in Company K, 126th Pennsylvania Volunteer Infantry and in Company M, 13th Regiment of New York Cavalry Volunteers. He was discharged due to a bullet in his liver, which he carried the rest of his life. While on a leave of absence in Washington, D.C., Snively found himself in the Ford's Theater saloon the night Lincoln was shot, after which he joined in the search for John Wilkes Booth. After the Civil War, he married Jane Irwin in the Greencastle Presbyterian Church. The Snivelys then moved to Missouri, Wyoming, Iowa, and Arizona and became some of the earliest settlers in the western part of the country. Snively was involved in the Grand Army of the Republic, ranching, livestock, mills, general mercantile stores, and real estate. He was elected to the Wyoming General Assembly for three sessions, serving as Speaker of the House for the ninth session. (Courtesy of Daniel F. Wolford.)

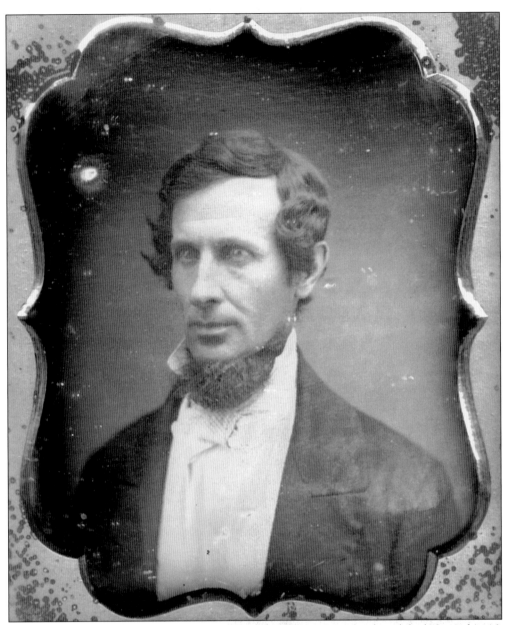

George W. Ziegler was born on April 30, 1810, in Leitersburg, Maryland, and died November 16, 1897. He arrived in Greencastle in 1833 and immediately became a junior partner in a mercantile business, of which he became sole owner in 1838. In 1850, his brother David joined him as a partner. Ziegler owned many real estate properties and was an underwriter and director of the Waynesboro-Greencastle-Mercersburg Turnpike. In 1870, he was one of the founders of the First National Bank. As a Republican, he supported the anti-slavery movement and was a delegate to the 1856 Republican convention that nominated John C. Freemont. John Brown, the infamous abolitionist, was also present at the 1856 convention. Although Ziegler's eldest son, George Frederick, was active in the business, Ziegler remained involved in making decisions about the Ziegler family holdings until his death. This daguerreotype of Ziegler was kept for over 160 years by the Ziegler family. (Courtesy of Martha Ziegler and George Frederick Ziegler IV.)

The image of Maria Fatzinger, seen in this daguerreotype, is a portrait painted by William D. Lechler, a well known portrait artist in the area. She was the wife of George W. Ziegler and together they had three children–George Frederick I, Maria E., and Theodore. Maria was born in 1817 and died at the young age of 30 in 1847. (Courtesy of Martha Ziegler and George Frederick Ziegler IV.)

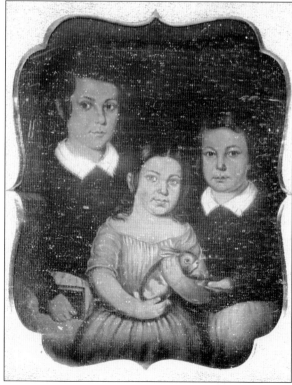

George W. and Maria had a portrait painted by William D. Lechler of their three children, which is seen here in a daguerreotype. Theodore died in 1849 at the age of four. His father wrote fondly of him in a letter he wrote home while on a business trip to Philadelphia. (Courtesy of Martha Ziegler and George Frederick Ziegler IV.)

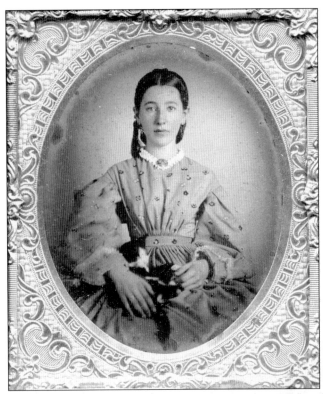

Maria E. Ziegler was the only daughter of George W. and his wife, Maria. During the Civil War, she wrote letters to her brother George. When the Confederate troops crossed the Mason-Dixon Line, five miles south of Greencastle, her father sent her to Philadelphia to keep her from harm. While there, Maria contracted pneumonia and died in July 1864 at the age of 17. (Courtesy of Martha Ziegler and George Frederick Ziegler IV.)

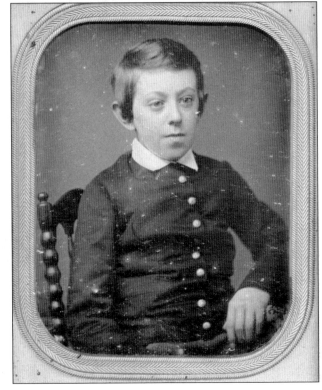

This young George Frederick Ziegler I grew to adulthood as the only surviving child of his parents. After starting college studies, he left to serve in the Civil War in Company K, 126th Pennsylvania Volunteer Infantry. Upon discharge, he resumed his education and graduated from Amherst College and the Princeton Theological Seminary. Along the way, he became enamored with glass plate photography. (Courtesy of Martha Ziegler and George Frederick Ziegler IV.)

Seven

NOTEWORTHY INDIVIDUALS REVISITED

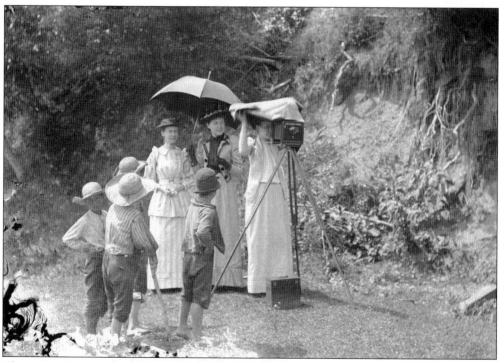

The cover photograph embodies the essence of the Images of America series. There is an old proverb, "Who writes, remains," and it can be similarly said for those behind the camera's eye who choose to record history using a different medium. This rare photograph from about 1892, showing a young lady "framing" a picture through the lens, is from the Ziegler collection of glass plate negatives. (Courtesy of Allison-Antrim Museum.)

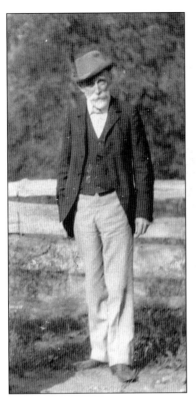

While attending college in the United States and abroad, opening a school in Greencastle, holding a professorship at Wilson College for Women, and attending to family-business matters, George Frederick Ziegler I also concentrated on his hobby of glass plate photography. Several generations later, Greencastle-Antrim residents are indebted to him for his legacy of 300 to 375 surviving glass plate negatives from between 1880 and 1910. (Courtesy of Allison-Antrim Museum.)

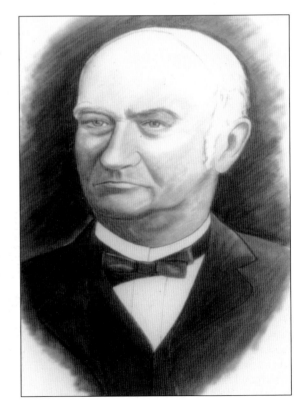

Jacob B. Crowell, who was born in March 1817, and died on September 26, 1901, was a school teacher, construction worker, bricklayer, industrialist, businessman, and bank president. He came to Greencastle in 1836 and worked as a bricklayer and school teacher. In 1850, he and George Bradley became partners in the foundry business. This began his half-century-long industrial legacy. He built Greencastle's first industrial park in the 300 block of South Washington Street. (Courtesy of the First National Bank of Greencastle.)

Anna Kreps Straley was born in Greencastle on January 1, 1846, and died on June 17, 1949, at the age of 103 years, five months, and 17 days. She was Franklin County's oldest resident, and said she lived, "like nature intended." On Straley's 102nd birthday, the Pennsylvania State Medical Society recognized her with a commemorative scroll and an orchid. In the photograph from left to right are Dr. Earl Glotfelty, Straley, and Dr. C. W. Lindeman. (Courtesy of Joyce Pensinger Berger.)

Adam B. and Mary Strite Zarger lived at 763 Zarger Road, where his grandparents Johannes and Elizabeth Zarger had lived and worked as tenant farmers for the Snively family beginning in 1824. Adam and Mary attended Antrim Grove School and private schools. Adam taught school and then worked on farming and in orchards and dealt in draft horses. He was elected registrar and recorder for Franklin County in 1899. (Courtesy of Ed Zarger.)

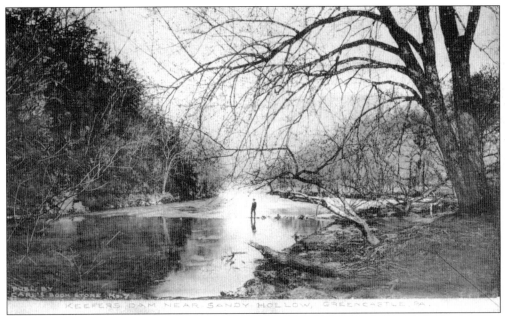

Pitt Carl, a stationer and telegraph operator, is perhaps best known for his picture postcards, which he sold of scenes around Greencastle and Antrim Township. Originally the postcards were bought and posted with notes to family and friends, but, today they are highly collectible reminders of the community's history. This postcard was a colorized version showing Keefer's dam, near Sandy Hollow. (Courtesy of Kenneth B. Shockey.)

After playing in minor league teams during the 1890s, Charles Reno "Togie" Pittenger (1871–1909) was then signed in 1900 by the Boston Braves; he was one of their top pitchers in 1902. Pittenger pitched right and batted left. He was traded to the Philadelphia Phillies, making him one of the first major league players to be traded. Pittenger died at the age of 37 after developing Bright's disease. (Courtesy of Allison-Antrim Museum.)

Before World War I, Greencastle had produced three major league baseball players—Albert Goetz, Pittenger, and Charles "King" Lear (1891–1976). Lear played for Mercersburg Academy and Princeton University, and in 1914, he signed with the Cincinnati Reds. His career ended two years later when he injured his throwing arm during training camp. Lear is the second from the left, with the Princeton *P* on his shirt, in the second row. (Courtesy of Franklin County Historical Society–Kittochtinny.)

Mary L. Harris was born on September 12, 1902, in Philadelphia. When her father died, her mother moved to Greencastle. After graduating, Harris studied stenotyping in Philadelphia and began working for the government. Her poetry, published in *Poetry for Twilight Listening* in 1974, expressed her love for God, church, life, and Greencastle. In 1987, Harris was honored with the Golden Poet of the Year award from the World Book of Poetry Association. (Courtesy of Mary Brooks Medina.)

Sgt. Harold "Penny" Pensinger was an avid photographer and operated the Pensinger family hardware business located at 27 Center Square. When he was called to serve in World War II, he was forced to close the business. Pensinger's expertise in photography was used by the army in the 256th Combat Engineers. Pensinger took hundreds photographs, including pictures of the death camps. His photographic legacy remains today. (Courtesy of Evelyn Pensinger.)

This is a picture of a photographer, Jarvis Henson, taking a photograph. Henson was well known around town for recording the history of his time on film. In addition, Henson ran the family bakery business on West Madison Street until around 1990. One of his most sought after baked goods were the soft pretzels. (Courtesy of Frank and Louise Mowen.)

Eight

SIGNS OF THE TIMES

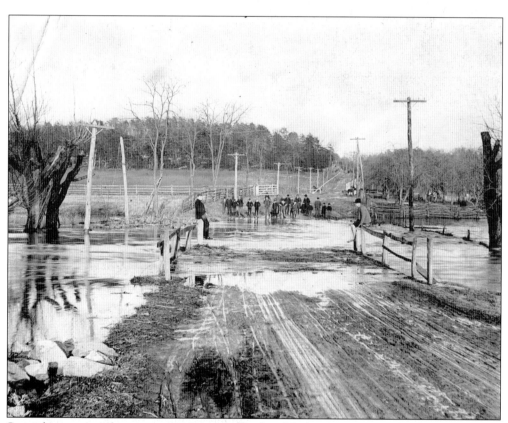

Some things never change over time, especially when Mother Nature is involved. With the flood waters raising into the meadow lands, this flooding of the Conococheague Creek could likely be considered a 100-year flood. The curious are always drawn to such happenings no matter how dangerous. The half-dozen young children in the photograph likely remembered this scene throughout their lives. (Courtesy of the Lilian S. Besore Memorial Library.)

The old must make room for the new. One of the original log structures of Greencastle was dismantled about 1940. The plans to construct a new post office on the site of the former Heck family building were postponed because of World War II. It then actually took another 20 years until the post office was dedicated on April 23, 1960. (Courtesy of Evelyn Pensinger.)

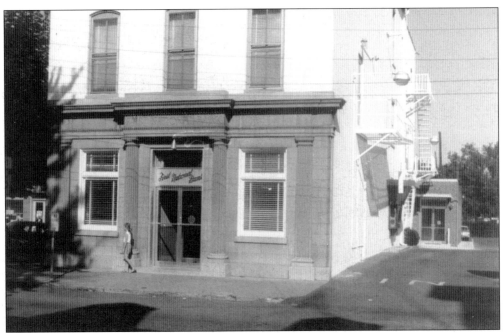

In 1922, the First National Bank's building was remodeled inside and out and was extended to the west, modernizing the 52-year-old building. A double-door entrance was created with pillars on either side, and a granite facade was applied to the first level. Returning to past times, the granite exterior was removed from the building between 1979 and 1980, during yet another interior and exterior remodeling project. (Courtesy of Elizabeth Martin.)

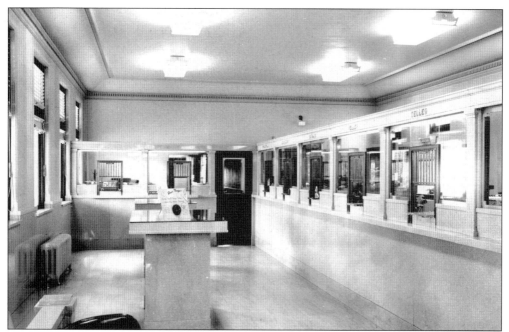

This interior view from around 1922 of the First National Bank's facilities is reminiscent of the times of the art deco era and shows the customer service area of the bank. Later the bars and windows were removed, leaving an open and more modern counter area for both customers and tellers. (Courtesy of the First National Bank.)

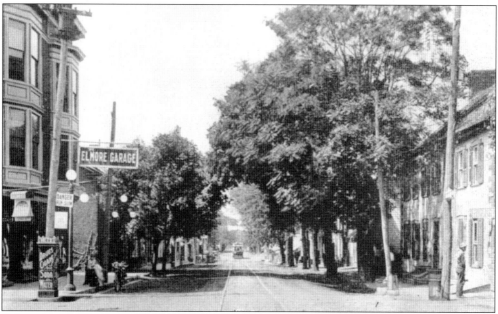

Below the Elmore Garage sign hangs another sign, which has not been seen since 1932. The "Danger Run Slow" sign was a warning and constant reminder to trolley car operators to slow down as they approached Center Square, where the trolley tracks came to an end, just before the railroad tracks. It is a sign of the times, which brings back fond memories to those who rode the trolleys between towns. (Courtesy of Allison-Antrim Museum.)

Before there were Xerox photocopying machines, there were mimeograph and ditto machines. A typewriter, as seen in the background of this 1947 photograph, was used to make the master copies for assignment sheets and tests; the mimeograph made copies that had bluish-purple ink (with its distinctive smell) and the ditto had black ink. Now one only needs to open a lid, close the lid, and press start. The woman is Helen Rowe Shank. (Courtesy of Jack Phillippy.)

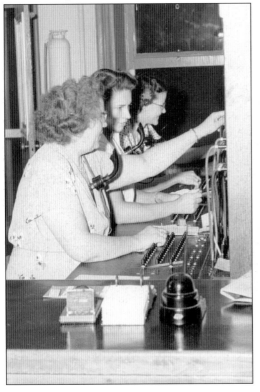

"Number please," has not been heard since February 1962 when the United Telephone Company changed from switchboard to direct-dial service in Greencastle. In the nine-by-six-inch 1959 telephone directory, Greencastle-Antrim listings filled 14.5 pages. The first number listed was for AAA (286) and the last listing was for T. D. Zullinger (193). The three Greencastle-Antrim's exchange operators in the photograph are, from front to back, Mary Hellane, Phyllis Foust, and unidentified. (Courtesy of Jack Phillippy.)

Times were changing. The new 1953 look of the Citizens National Bank (now Susquehanna Bank) also included an annex on the east end of the bank and a drive-in window on the south side, which was the first in Greencastle. To make room for customer parking, the property at 27 South Carlisle Street was purchased and razed. The modern brick structure of today was completed in 1976. (Courtesy of Elizabeth Martin.)

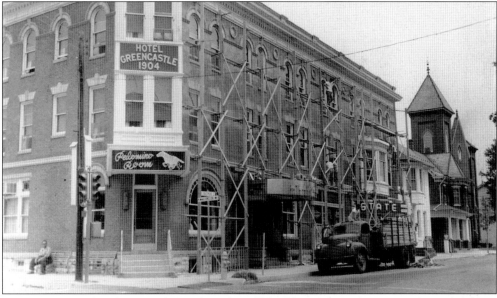

In 1959, it was the thing to do: update the old buildings in town to give them a modern appearance by cementing a white-brick facade to the outside. This photograph shows the Hotel Greencastle. The modernization of Greencastle was one of six project goals that the Greencastle-Antrim Area Development Corporation accomplished during 1960. The development corporation was established under the auspices of the chamber of commerce. (Courtesy of Allison-Antrim Museum.)

The same white-brick facade was also added to the Franklin House at 11 North Carlisle Street, which then was removed about 1978. The other five chamber initiatives were: to bring new industry to Greencastle-Antrim (including Corning Glass Works, a new post office, and a new high school), to improve the water system, to construct a new water tank, to erect new street signs, and to host a visit by Miss America. All six projects were accomplished. (Courtesy of Allison-Antrim Museum.)

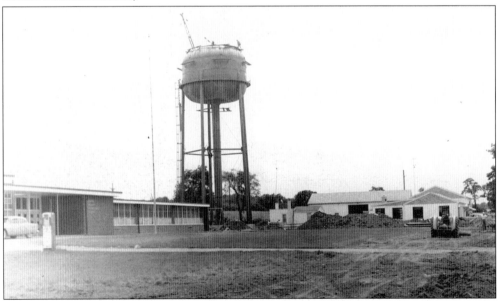

The signs of cooperative efforts were evident. The Greencastle-Antrim School District board of directors, the Antrim Township board of supervisors, and the borough council members worked together to build a 250,000 gallon, elevated water storage tank on the property at 842 South Washington Street. The existence of the water tank was crucial in Corning Glass Works making the final decision to build its plant in Antrim Township. (Courtesy of Allison-Antrim Museum.)

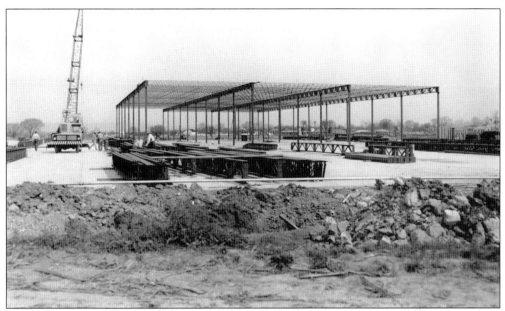

From February 24, 1960, when it was announced that Corning Glass Works was going to build a plant at 1200 South Antrim Way, it only took four months until the project was completed on June 20, 1960. It was estimated that, initially, the 600,000-square-foot plant would provide 150 new jobs in the Greencastle-Antrim community. (Courtesy of Allison-Antrim Museum.)

In 1960, new metal street identification signs were erected within the borough limits through cooperation between the borough of Greencastle and the chamber of commerce. These signs are located on the southern border of the Orchard Circle housing development; the school district property lies behind the houses. (Courtesy of Allison-Antrim Museum.)

After the first oil embargo on October 17, 1973, these signs of the times vanished. Andy Anderson's ESSO station on South Antrim Way sold regular gas for .31⁹/₁₀¢ per gallon; today it is $2.75⁹/₁₀. The Organization of Petroleum Exporting Countries decided not to export petroleum to Israel's allies, relative to its conflict with Syria. Drivers with odd-numbered plates could only purchase gas on odd-numbered days and vice versa. (Courtesy of Elizabeth Martin.)

Some things will never change through the passage of time. The pile of stones is a sign of an error in judgment made by a driver trying to navigate around the center of Greencastle's square. This repetitive error has caused the stone work to be re-laid numerous times over the decades. This photograph shows what may have been the first time, around 1955, but it was not the last. (Courtesy of Allison-Antrim Museum.)

Nine

EVENTS AND PASTIMES REVISITED

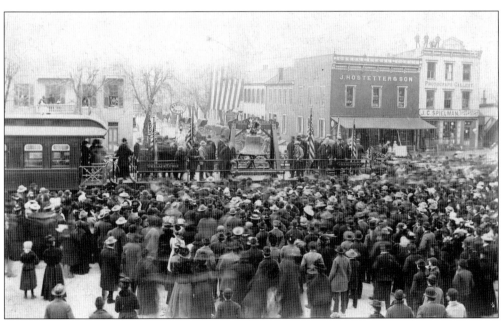

On Monday, January 6, 1902, 105 years ago, the *Liberty Bell Special* stopped in Greencastle's diamond on its way to a special exhibition in Charleston, South Carolina. The unique occasion drew hundreds of people who maneuvered to get the best view, whether it was only feet from the train, or in second- and third-floor windows, or on rooftops. All along the way, from Philadelphia to Charleston, thousands lined the rails. (Courtesy of Mary Ziegler Glockner.)

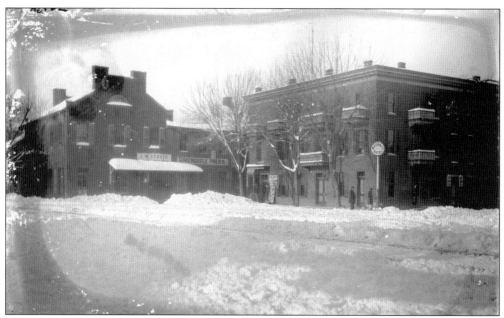

On the right side of the photograph from around 1885, it is quite evident that the only path through the snowy square was made by the trains. The walkway between the crossings at the corners of the square and the sidewalks were hand-shoveled. With no snow plows, the square remained as is. Transportation, if one needed to go somewhere, would likely have been by sleigh. (Courtesy of Allison-Antrim Museum.)

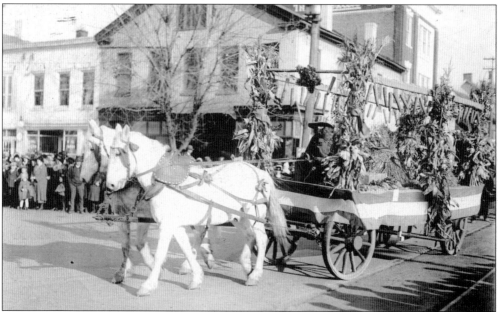

In 1925, the farmers of Antrim Township organized a parade, "From the Field to the Table." There were many wagons elaborately decorated with the fruits of the harvest. This one used corn shocks and ears of husked field corn, which dangled like fringe. The driver is wearing a costume beard and decorated hat. From the back corner of the wagon peers a scarecrow-like face. (Courtesy of Jean Oliver Reymer and Robert C. Reymer Jr.)

Leland and Lorraine Wilson, of California, would make their living by annually traveling to the East Coast and back in their Conestoga wagon, which was pulled by a bison, and stayed at farms such as Christian Musselman's. The Wilson's sent word ahead of time about the location of their stay, and invited people to have photographs taken with the bison for a fee. This photograph of Christian Musselman was taken on May 15, 1939. (Courtesy of Terry Musselman.)

Fires anywhere are major events, but especially so in a downtown area where the structures are 100 years old or more. On one unfortunate occasion, Merle Hollinger's two-lane bowling alley and pool room at 29 Center Square caught on fire, which brought fire engines, hoses, and many people to downtown. Fortunately Rescue Hose Company No. 1 arrived in time to extinguish the fire and saved the building. (Courtesy of Joyce Pensinger Berger.)

Precariously straddling the south wall of the five-arch limestone bridge that was once located about one mile west of town, rescue workers try to stabilize the 1938 Cadillac with cables so that an early tow truck could hoist it back onto the bridge. It is difficult to imagine what caused Harry W. McLaughlin, owner of the McLaughlin Hotel, to go through the wall at a 90-degree angle. (Courtesy of Joyce Pensinger Berger.)

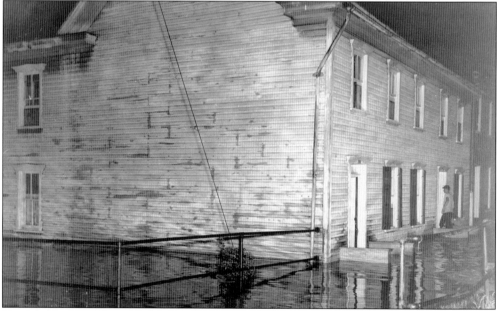

On the occasion of heavy rains, some low-lying areas of Greencastle and Antrim Township are notorious for flooding. In the 1940s and 1950s, one such area in town was at 104 South Carlisle Street, where the foundation of this house sits about six feet lower than the roadbed. Rescue Hose Company No. 1 pumped the water out and let it flow down West Franklin Street's Foundry Hill toward the underpass. (Courtesy of Jack Phillippy.)

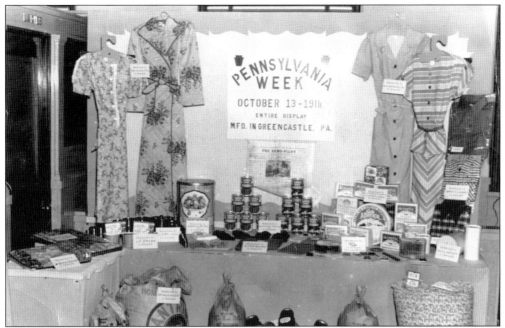

During the week of October 13–19, 1940, Greencastle celebrated Pennsylvania Week with a display of items grown, made, manufactured, or processed in Greencastle. Some of the businesses included Gem Garment Company, Omwake and Oliver, Baumgardner's Orchards, J. F. Brown, William's Bakery, E. L. M. Feed, Echo Pilot newspaper, Sunshine Brand, Greencastle Packing, and Victor Hosiery. (Courtesy of Jean Oliver Reymer and Robert C. Reymer Jr.)

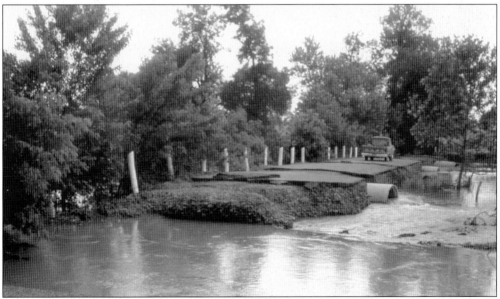

On June 22, 1972, tropical storm Agnes hit the area. It was Pennsylvania's worst natural disaster. Within two days, 18 inches of rain fell and everyone wondered if it would stop. The aftermath of the storm was felt all along the Conococheague Creek. Martin's Mill Covered Bridge was swept from its moorings and Kuhn Road, just north of the bridge at the intersection with Rabbit Road North, was wiped out. The meadows were flooded for weeks. (Photograph by Kenneth B. Shockey.)

"It's come at last; at last it's come." On February 2–4, 1967, *Bye, Bye, Birdie*, the first all-school musical, was presented to sold-out audiences. The success was due to nearly 100 dedicated students and faculty who worked together. On stage from left to right are Jim Shockey as Conrad Birdie, Don Spitz as Mr. MacAfee, and Cheryl Spitz Pietsch as Kim MacAfee. (Courtesy of Bonnie A. Shockey.)

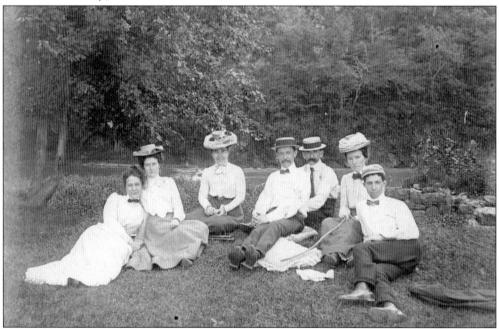

Members of the Ruthrauff and Omwake families of Greencastle and Antrim Township are seen here during a social outing along a waterway, perhaps near the Conococheague Creek or Muddy Run. Outings such as this were one of the ways young people could socialize. (Courtesy of Martha Ziegler.)

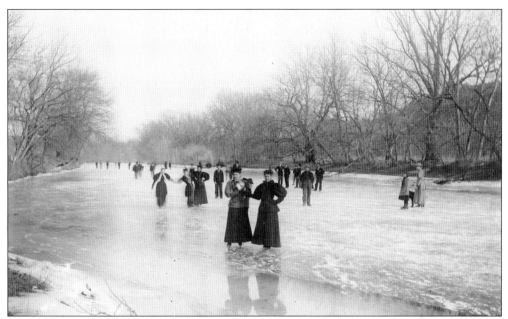

During the 1800s, favorite wintertime recreation included ice-skating and coasting (sledding) parties, which often concluded at the home of one of the individuals for hot chocolate. These ice-skaters are likely gathered at the first dam's pond, which was located just southwest of town. Today warmer winter temperatures do not allow ponds in this area to freeze thick enough for ice-skating. (Courtesy of Mary Ziegler Glockner.)

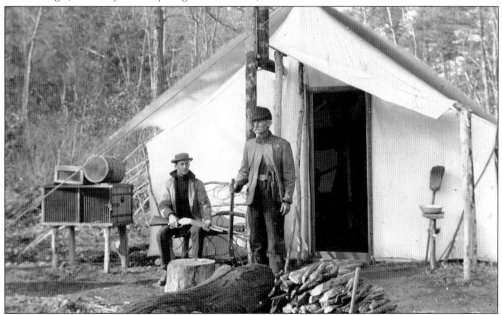

For some men, hunting camps served as pastimes during the late 1800s. These two men are displaying their hunting attire and the gear (knives and rifles) they used around 1895. The canvas tent appears to be quite substantial, and with the comforts of home—water, wash basin, broom, bentwood seating, and lots of firewood, it was likely a lengthy hunting trip. The photograph is from the Ziegler glass plate collection. (Courtesy of Allison-Antrim Museum.)

The call of the outdoors beckoned all ages. Favorite activities during summertime in the 1800s included hiking, canoeing, swimming, bicycling, and caving. These five young lads arrived at this location by horse and carriage to enjoy exploring the woods, rocks, and fresh air—far different than anywhere in town. The photograph is from the Ziegler glass plate collection. (Courtesy of Allison-Antrim Museum.)

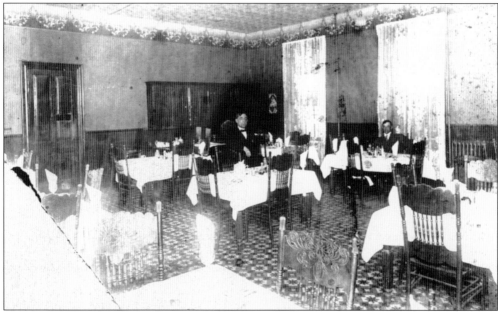

William Conrad wrote, "Coming to Greencastle to dine in its downtown center of gustatory delight had a long, long tradition." In this 1914 photograph of the Franklin Hotel's dining room, one can see the fine dining experience was worth the trip to see the lofty ceiling of pressed tin, the ambience of gas lights, the spacious room, and dining tables set with china and silver. If only one could taste the cuisine. (Courtesy of the Lilian S. Besore Memorial Library.)

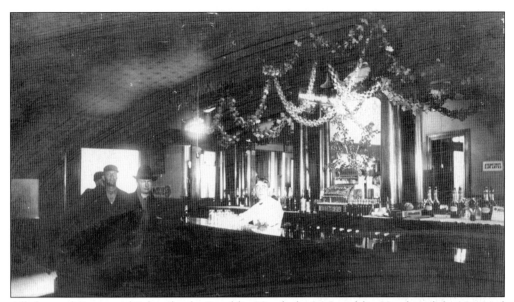

All three of Greencastle's hotels, the Franklin Hotel, the McLaughlin Hotel, and the National Hotel, had fine dining rooms and a bar area. Seen here in this 1914 Christmas season photograph is David Shirey, the proprietor of the Franklin Hotel, behind the bar. Prohibition, between 1920 and 1933, sounded the death knell for the hotel barrooms. (Courtesy of the Lilian S. Besore Memorial Library.)

In addition to the hotel restaurants, the Franklin House cellar restaurant, run by Jimmy Carpenter, served ham and oyster sandwiches. At the McLaughlin Hotel underground eatery, Elmer Pentz's fare was beef tongue or limburger cheese sandwiches. Sublevel at 29 Center Square, Cletus Zimmerman's Bucket of Blood and Roy Neady's Restaurant served soup, sandwiches, and pies for lunch. (Courtesy of Joyce Pensinger Berger.)

Prior to television getting a foothold in the living room, radio provided family entertainment. From Greencastle, Merle Everts and the *Hilltop Harmonizers*, which sang country music, were regular performers every Saturday morning on WAYZ radio in Waynesboro. In this *c.* 1952 photograph from left to right are (kneeling) Everts; (second row) Linda Everts Murray and Juanita Everts; (third row) Charles Schaff, Hylda Everts, Carolyn Hissong Waltz, Faye Everts Mentzer, and Leo Peck. (Courtesy of Benjamin Thomas Jr.)

The voices of these three gentlemen were more familiar than their faces. From left to right are Brian Simmers, Wade Burkholder, and well-known morning deejay "Cousin" Harry Gettle. They were broadcasting from a live remote location at Sunnyway Food Market when this photograph was taken. They all worked for WKSL 94.3 FM in Greencastle. WKSL was established by Benjamin Thomas Sr. in 1967. The 94.3 airwaves fell silent in 1997. (Courtesy of Benjamin Thomas Jr.)

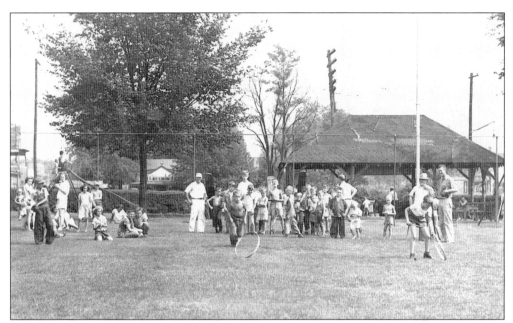

The Jerome R. King Playground was a very special gift from David D. King to the Greencastle-Antrim community during Old Home Week in 1923. Children's programs and events like Playground Day in 1946 have been held annually. Bob Kugler (left) and Howard "Pete" Wolfinger are trying to keep the hoops rolling. On the far right is playground supervisor William Conrad. The photograph was taken by Alex Morganthal. (Courtesy of Bob Kugler.)

When the rescue company's minstrel show fund-raiser began in 1929, garishly dressed end men like Sambo Mowen were, and still are, responsible for making people laugh by telling jokes, stories, and picking on audience and community members. They also have a repertoire of songs that they sing while backed up by the chorus. This 1933 photograph was taken in front of one of the ticket boxes outside the Gem Theater. (Courtesy of Rescue Hose Company No. 1.)

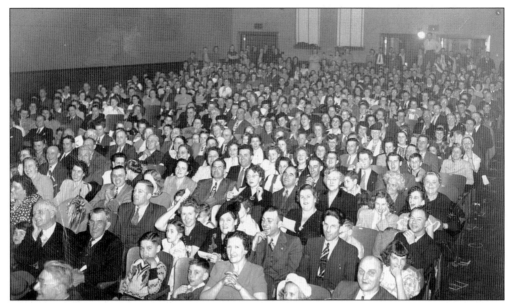

Since 1929, the Rescue Hose Company No. 1's minstrel show has been one of the largest attended annual events in the Greencastle-Antrim community. This full-house audience was seated in the auditorium of the South Washington Street high school around 1948. The minstrel show began as a fund-raiser for the Rescue Hose Company No. 1 and continues as such. Its longevity is due to the talents of community members who are willing to practice for a couple of months each year. (Courtesy of Rescue Hose Company No. 1.)

Merle and Genevieve "Gem" Hollinger owned Mo's at 30 South Washington Street, next to the high school, which was a 1940s teen hangout. As the school did not have lunch facilities, teens either walked home for lunch, packed lunch, or ate at one of the nearby eateries. There also were two large rooms where these teens from the class of 1947 could practice ballroom dancing, which was taught over lunchtime at the high school. (Courtesy of Gladys Oaks McCrae.)

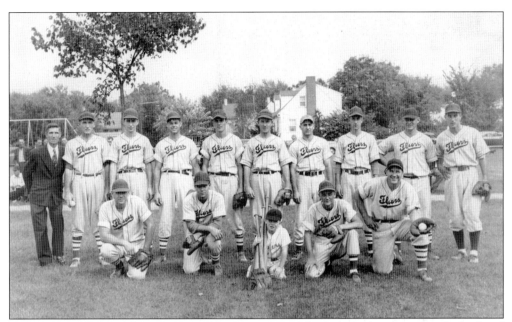

The 1947 Middleburg Fliers champion team was part of the Independent League, which played teams from Washington County, Maryland. The name of the team was chosen because of the proximity of the new air field south of town. An outstanding early player was pitcher Ted Brumbaugh, pictured here on the right end of the second row, who played for the Washington Senators farm teams. (Courtesy of Middleburg/Mason-Dixon Line Historical Society.)

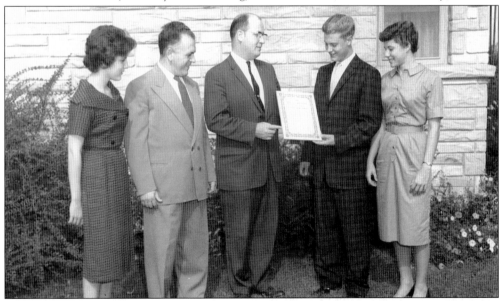

On October 1, 1960, the Greencastle-Antrim Youth Canteen, which met in the high school gymnasium, received a fourth-place award for outstanding service to the community from *Parents* magazine. The local canteen was one of only 10 Pennsylvania youth organizations to receive the honor. In the photograph from left to right are Mersina Barbuzanes Barnett, Nick Barbuzanes Sr., Rep. William O. (Bill) Shuman, Larry Thomas, and Kay Smith Boward, who was the 1960 Canteen Queen. (Courtesy of the Allison-Antrim Museum.)

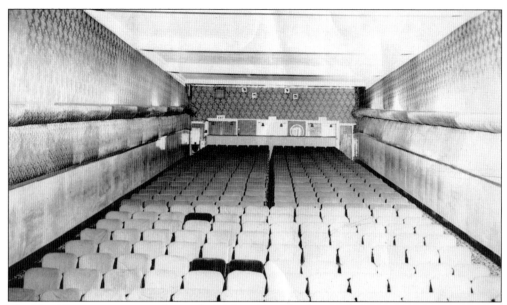

The Gem Theater was annexed onto the McLaughlin Hotel around 1912. In 1933, a theater chain bought the business and renamed it the State Theater. The inside of the theater, looking toward the projection room, is seen in this photograph. Over the years, the facility was a community auditorium for silent movies, talkies, commencement exercises, school plays, minstrel shows, some vaudeville acts, and talent shows. It closed on July 1, 1962. (Courtesy of the Lilian S. Besore Memorial Library.)

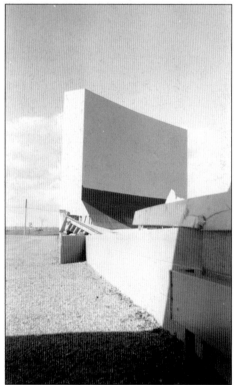

In the mid-1950s, State Line Drive-in Theater opened, allowing theatergoers to not have to get out of their cars unless they wanted popcorn, drinks, or other standard theater snacks. Cars parked in spots that were equipped with a speaker box, which hung over the open car window. It was the 1950s equivalent of an IMAX-size screen. This photograph was taken after a freak storm on February 25, 1956, that had 104 mile per hour winds. The theater closed around 1978. (Courtesy of Harry Tressler.)

Ten

OLD HOME WEEK
REVISITED

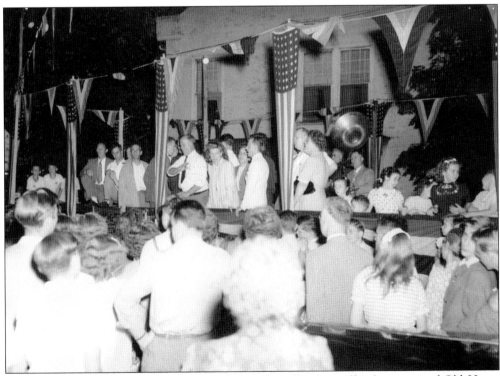

The night was Sunday, August 3, 1947, during the official, unofficial opening of Old Home Week. Tradition holds that all revelers gather on the square prior to midnight and wait for the town clock to strike 12. As it does so, those in the square break into a hardy rendition of "The Old Gray Mare." And so begins Old Home Week, once again. (Courtesy of Evelyn Pensinger.)

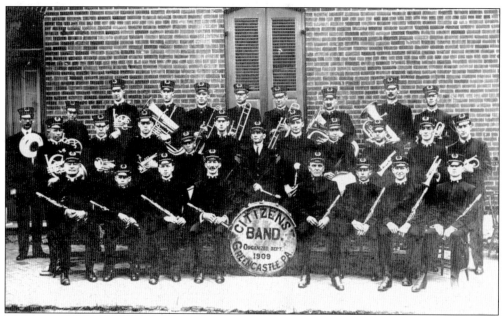

The Greencastle Citizens Band organized in September 1909 and, according to the Old Home Week 1911 program, played several concerts during the week-long celebration. It was a short-lived band, as the Old Home Week programs for 1914 and 1917 do not mention any band concerts. The Junior Order of United American Mechanics Band provided music for special occasions before 1909 and from 1912 to 1926. (Courtesy of Don and Sandy Parks Didio.)

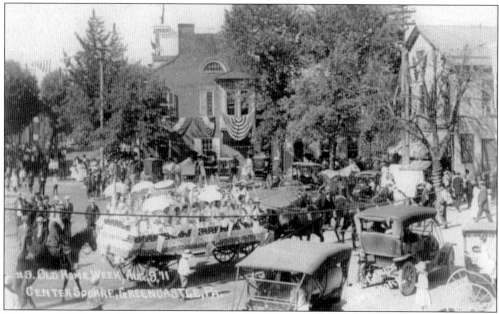

Greencastle's diamond has always provided a central stage for many of the Old Home Week events, as is seen in this Carl's Book Store postcard from Wednesday, August 9, 1911. That year marked the fourth triennial celebration, and the square was a bustling center of activity with people on foot, floats on horse-drawn wagons, horses and carriages, and horseless carriages. (Courtesy of Don and Ruth Coldsmith.)

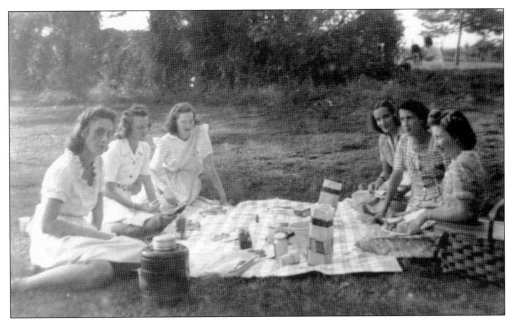

During Old Home Week in 1941, this group of six young women enjoyed a picnic lunch during the festivities. Old Home Week is about making time to reminisce with friends, whether old or new, about growing up in Greencastle and Antrim Township. Pictured from left to right are Nan Conrad Flaherty, G. Margaretta Williams, Alice Holstein Bartholomew, Jane Homer, Jane Conrad Alexander, and Jean ?. (Courtesy of Allison-Antrim Museum.)

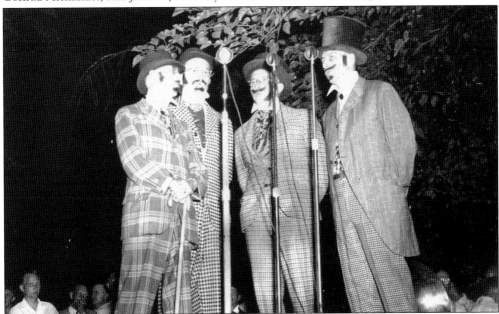

The Moss Spring Barber Shop Quartet never left the house without first wearing their best attire. The group, well known throughout the region, performed for numerous functions over the years, including Old Home Week. They provided great enjoyment to both young and old. Pictured from left to right are Ellis Izer, Paul Foust, Paul Zeger, and Harold Pensinger. (Courtesy of the Lilian S. Besore Library.)

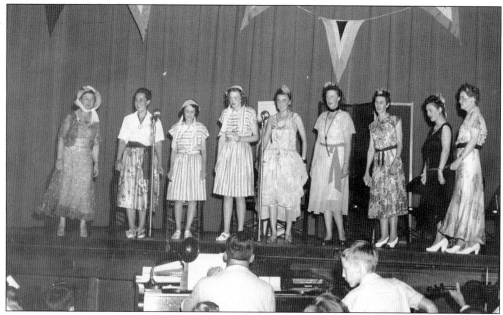

There is no doubt that these ladies were participating in an Old Home Week event, most likely the pageant, which was performed on Tuesday and Wednesday evenings during the triennial celebration. In 1947, the pageant was held in the auditorium of the old high school, which was located at the corner of South Washington and East Franklin Streets. (Courtesy of Allison-Antrim Museum.)

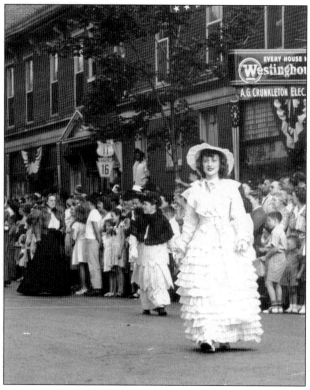

The Old Home Week parade of 1947 was held on Thursday, August 7. In this photograph, the costumed parade participants are entering the square from East Baltimore Street. Dressing in period costume has been part of the triennial event for many years, in both the pageant and the parade. Pictured from the left to the right are Miriam "Polly" Zullinger in the black skirt and white blouse, unidentified, and Evelyn Zullinger Pensinger. (Courtesy of Evelyn Pensinger.)

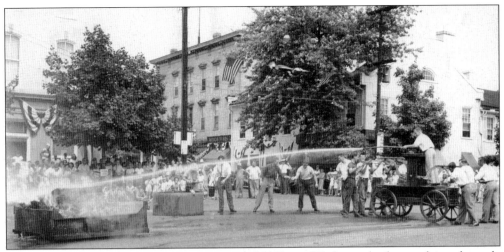

Rescue Hose Company No. 1's participation in Old Home Week goes back to, at least, the early 1930s, and likely before that. In this photograph, the historic *c.* 1741 hand pumper is being demonstrated to a crowd of onlookers, proving, that over 200 years later, it most certainly can extinguish a fire. (Courtesy of Jack Phillippy.)

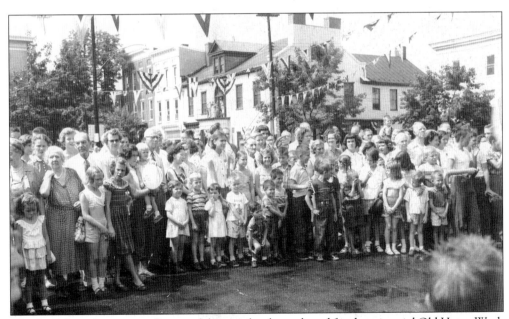

Charles F. Besecker captured some of the people who gathered for the triennial Old Home Week photograph sometime in the 1950s. During the week-long celebration, activities and events involve everyone, including grandparents, parents, and children. The youth of Greencastle-Antrim are the reason that Old Home Week has continued for 105 years. They watch, remember, join in, catch the Old Home Week spirit, and then pass it on. (Courtesy of Allison-Antrim Museum.)

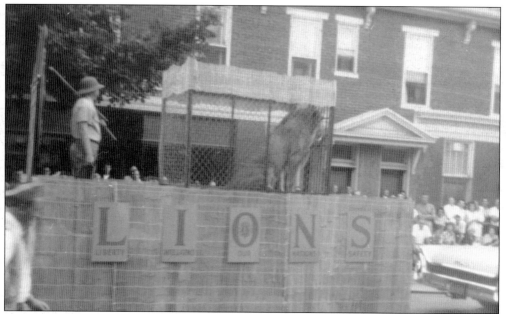

During the 1956 Old Home Week parade, the Greencastle-Antrim Lions Club entered a float. To the delight and wonderment of the spectators, especially the children, there was a real lion in a cage on the float. The lion was rented from a company in York. Tom Stouffer, president of the Lions Club, is on the float and was well supplied with lots of red meat during the parade. (Courtesy of Edwin C. Bittner.)

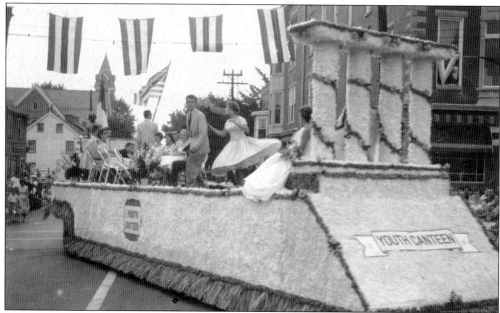

The Youth Canteen, established in 1954, sponsored a float in an Old Home Week parade, in either 1956 or 1959. Music was playing and the teenagers were dancing, as the large float entered the square from West Baltimore Street. The sport jacket and tie, considered dressy today, was the norm for young men attending a dance in the 1950s. The young lady's dress and crinolines are reminiscent of fashion magazines from the 1950s. (Courtesy of Edwin C. Bittner.)

The grand finale of the Old Home Week celebration is an outstanding, nonstop, 30-minute display of fireworks, which delight the senses with a rainbow of colors and sounds of sizzle, pop, and bang. The feeling of anticipation that leads up to the unofficial opening is followed by a whirlwind-week of activities that fills everyone with the Old Home Week spirit. When the night sky becomes dark after the last flash of color and the smell of gunpowder hangs heavy in the air, there is a sadness that yet another triennial has come to an end. Consolation comes with knowing that in two short years, friends in Greencastle-Antrim will gather again, once a month, in preparation for the next Old Home Week. (Photograph by Kenneth B. Shockey.)

ACROSS AMERICA, PEOPLE ARE DISCOVERING SOMETHING WONDERFUL. THEIR HERITAGE.

Arcadia Publishing is the leading local history publisher in the United States. With more than 3,000 titles in print and hundreds of new titles released every year, Arcadia has extensive specialized experience chronicling the history of communities and celebrating America's hidden stories, bringing to life the people, places, and events from the past. To discover the history of other communities across the nation, please visit:

www.arcadiapublishing.com

Customized search tools allow you to find regional history books about the town where you grew up, the cities where your friends and family live, the town where your parents met, or even that retirement spot you've been dreaming about.